THE
TALENT
MYTH

FREEING THE ARTIST IN YOU

by
Larry Gluck

Second Edition

Renaissance Publications
5744 San Fernando Road
Glendale, CA 91202

Grateful acknowledgement is made to
the L. Ron Hubbard Library for permission
to reproduce selections from the copyrighted
works of L. Ron Hubbard. © 1991
L. Ron Hubbard Library

I/A #040911 WUS

To order additional copies of
The Talent Myth visit
www.thegluckmethod.com
or contact:
Renaissance Publications
5744 San Fernando Road
Glendale, CA 91202
1-800-430-4278

Library of Congress card number:
00-101985

Gluck, Larry
The Talent Myth

ISBN # 1-929473-00-1

ACKNOWLEDGMENTS

The wondrous painter *Giuseppi Trotta* allowed the adolescent me to see true greatness, as well as witness the consummate love of an artist for his art form.

Allowing me to taste the fruits of artistic success through my painting and recording their colorful lifestyle, the endearing and gracious *people of St. Thomas* in the United States Virgin Islands provided a springboard from which I could make the leap into art education.

And how can one say enough about someone who inspired me to pursue so awesome a task as reinstating the basics of fine art and making them approachable to one and all? American artist, philosopher, educator and humanitarian *L. Ron Hubbard* exhibited for me the fortitude and the format upon which to construct a new way of instructing art.

Additionally, hundreds of *Mission: Renaissance staff and instructors* at my side for more than twenty-five years have helped thousands of people of all ages gain the freedom to draw and paint beautifully. All of them have my gratitude.

Trevor Meldal-Johnsen first set my thoughts into written words fifteen years ago and suffered lo these many years with my trials and tribulations about

completing the book. Thanks also to *Peter Gelfan* who tied the bow with his final edits.

Finally, there is always that one "unfortunate" who must bear the brunt of an unsolicited adventure with someone like me. My wife *Sheila* helped from the beginning, putting up with my foibles and disabilities—in particular, my lackluster writing skills. Sitting for endless hours patching sentence structure, she kept hoping it would all go away, but when it didn't she still continued, each time, and helped place the final period.

TABLE OF CONTENTS

PROLOGUE

Are you one of millions of people who once had the desire to create?

Did you once dream of artistic success? Have you ever wanted to act, write, draw, paint, sculpt, dance or sing? Did you play a musical instrument as a child and then give it up?

What happened?

Perhaps, like countless others, you thought you lacked the natural talent needed to succeed as an artist.

Written for anyone who has ever dreamed of artistic success, this book has a simple message: it's never too late, the creative urge never dies, and you can still have a personal renaissance.

The research, ideas and information summarized in this book were gathered over half a century of hard-won experience as an artist and teacher. After having achieved some renown as a painter, I became challenged by the idea of teaching others what I knew. My purpose was simple and clear: to teach the traditional basic skills of drawing and painting in a way whereby I could help to produce some great painters. What began as a personal challenge has become the world's largest fine-art training program.

However, along the way I found that anyone, with or without natural talent, could learn to draw and paint beautifully.

I and instructors trained in my methods have helped thousands begin glorious new adventures. Some students had natural abilities, but most began with little more than the desire to learn and again taste the fruits of creativity. Most were afraid and skeptical of their chances before they began, yet with step-by-step, one-on-one instruction, they have succeeded.

Only a handful of the general public knows the joy and riches artistic creation can bring, the enhancement in mental and physical well-being, the transcendent moments in a life sustained by the arts. I have seen lives revitalized when creative goals were rekindled and a missing piece to life's puzzle fell into place.

The creative impulse, even if barred, keeps trying to break free. It doesn't die or go away. It has enormous power. No matter how ignored or denied or betrayed, it makes its presence felt throughout a lifetime.

Although the book focuses on painting, much of the material applies to the other arts as well. Many of my students who have careers as writers, actors, musicians, and dancers have taken the principles they learned about drawing and painting and used them to lift their professions to new levels of expression and success.

The Talent Myth exposes the major obstacle to artistic success — one that has caused millions to give up their artistic pursuits — and unmasks our wasteful system of educating artists, a system that actually prevents the development of talent. I discuss the true nature of talent, the fundamentals that appear to hold true for creating all fine art, and the standards and methods I believe necessary to successfully teach and learn an art form. *The Talent Myth* is a guide to help anyone get started as an artist or revitalize his goals in the arts.

The waters of the arts have been muddied for too long. Perhaps this book, this tiny stone hurled into the forbidding center of the old, stagnant seas, will spread rings of truth that will dispel enough of the murk to make the waters inviting for all.

PART I

Every child is an artist.
The problem is
to remain an artist
once he grows up.
– Pablo Picasso

THE MYTH

OUR FAVORITE LIE

Most of us think that in order to pursue the arts and be creative, we first need natural talent. We've been sold a bill of goods — *The Talent Myth*.

If you don't believe me, it's understandable. Most likely you've never thought it possible to acquire talent. The talent myth promotes the lie that unless one has a large endowment of natural talent, one has no real chance to develop artistically.

Look up the word *talent* in a dictionary and you will find that even our language perpetuates the myth about it being naturally endowed. Yet talent really just describes the ability to perform in a certain field. Ability depends on skills and any skill can be learned. The Latin and Greek roots for the word *talent* originally meant "a unit of weight and/or money" — something valuable, yes, but certainly not innate. Over time, the meaning of the word altered and diminished, leaving the impression that only those born with enormous gifts can succeed.

It isn't true.

An unfortunate by-product of the myth is the notion that no real knowledge exists in the arts. You simply and magically have talent or you don't. No basic knowledge exists, only individual accomplishment.

Yet if he stops to think about it, an intelligent person will realize that any activity can be broken down into fundamental steps and learned—even art.

You don't have to be born with talent, you can acquire it.

PUBLIC ENEMY NUMBER ONE

The talent myth is built on fear of failure. So solidly is it entrenched in our thinking, it's like pulling teeth to convince people of its treachery.

Why has this myth persisted for so long? For one thing, it has helped leaders rule their subjects, convincing them that only the few very gifted are truly creative. For everyone else, the sole worthwhile activity has been to work, certainly not to "play" at art. Artistic self-expression does little to fill treasuries and pay taxes. Being creative brings about individuality, discovery, new ideas and change. Leaders certainly have wanted as little of these as possible rocking the ship of state.

As keeping art scarce jacks up its price and helps fill the coffers of those in control of this rare commodity, the myth aids and abets the rich and powerful who have always surrounded themselves with and

supported the most sought-after artists—a profitable arrangement for art owners and those few artists. This situation is as true now as it was centuries ago.

The talent myth also protects artists who feel threatened by competition, allowing a small number to hoard success and power. Working artists are often reluctant to pass on their hard-won secrets, especially since their unique, enviable positions confer status and riches. Why should they help the competition with so small a creative pie to divide?

But let's not forget that the talent myth has also served as a wonderful excuse for millions of people to skirt a confrontation with the scary challenge of developing their own talents. Artists love what they do and work hard to achieve excellence. Nearly all who are successful have won through their own persistence, by searching for the right instruction and by pushing themselves towards more and more ability.

People give dozens of excuses not to indulge in artistic creativity, but there is really only one reason: fear of failure. And our talent myth stands front and center to justify it all.

This mammoth myth has stalked the centuries, insidiously robbing people of their creative potential. It has all but censored humanity's otherwise vast abundance of artistic creativity and dammed its potential to a trickle.

Yet despite this, the arts have played the starring role in civilizing the human race. One lone poet,

Petrarch, penned a love poem that sparked the great Renaissance. Before we put men on the moon, H.G. Wells wrote about it. There are many such examples. It is impossible to estimate the positive changes that might have been ours if it were not for the talent myth.

The myth has brought about an astonishing scenario: we have a few great artists, a very expensive game of collecting their works, and millions of individuals who swear "I could never do that."

The talent myth is Public Enemy Number One. For centuries, everyone — those who create and those who do not — have been on its hit list.

THE MYTH RIDES AGAIN

Like a slick outlaw, the cunning myth covers its own tracks. It has a simple, built-in, nearly infallible ally — our blind acceptance of its credibility.

Nearly everyone sees only what the myth projects. Every truly brilliant artist trained for years. I know of no exceptions. Yet when admiring them we speak only of their vast natural talent, never the years of disciplined training and apprenticeship it took to acquire the amount of talent that finally made their works so superb. Do you think of a Michelangelo or Leonardo as having *acquired* talent?

Though education is supposed to enlighten and help an individual, most art educators have their heads cemented in the talent myth. Many writing

teachers will say, "Good writing can't be taught. A student must have talent or it's hopeless." Art teachers make similar remarks. It's probably true of teachers of acting, dance, and other arts. It may never have crossed their minds to help someone without natural gifts, even though so many people have a fierce desire to learn.

How invincible is the talent myth? A homemaker with no apparent natural talent came to me for instruction. But she was courageous and possessed the desire and will to learn.

I started her on the rock-bottom basics of drawing. She persisted, learned to draw, and in time became highly adept with pastels. After toying with the idea of exhibiting—a big step for any artist—she entered her work in an outdoor art show. A few days later she burst into the studio with the exciting news of her $1,400 first-ever sale.

As we talked, she grew serious and said, "Whenever I meet someone who likes my work, I tell them I started from scratch without an ounce of natural talent, and they could learn too. You know what every one of them says? 'Oh, no. I could never learn to do that.'" Even her closest friends refuse to admit that she acquired her skills. Unable to accept the truth, instead they believe she had natural talents that had lain dormant since birth. Like some mythological beast, the talent myth even when wounded heals itself in an instant without loss of its lifeblood—its credibility.

WE LOVE A MYSTERY

People love the notion that talent is a mysterious gift from God and only a few lucky beneficiaries are blessed. Or that it's in the genes, or comes from some lucky roll of the dice. Ordinary mortals admire talented artists with awe and envy. Instead of believing you can also learn, have you, too, set the talented apart and endowed them with mysterious powers far beyond your own?

Then how do you explain the writer who struggles through five novels before someone publishes his work, or the singer who has voice lessons for twelve years before launching an exciting career? Does talent only belong to the writer who instantly gets published or the singer who succeeds without a lesson?

We start with whatever ability we have, but from then on it's up to us. The writer who begins with only a strong desire but who works hard to learn his craft can become as good a writer as the gifted one who quickly dashes off the latest bestseller.

Only by our ignoring the truth can a myth persist. Sometimes we may even desire its persistence. I once showed an art collector a painting of mine that intrigued him no end. He had no idea how I'd achieved that particular effect and asked me to show him how I'd done it. I did and he immediately grew upset. The mystery was gone; I had ruined his fun.

When we unthinkingly agree to an untruth, a talent myth can become a tyrant king — to tread upon

our once bright dreams and bludgeon us into forgetting we can learn.

However, every so often the specter of the urge to create haunts us and taunts us to try our hand at art again. Perhaps strolling through a museum evokes pangs of desire to paint, or a night at the theater stimulates a yearning to act. The urge to create struggles to emerge and remind us that there is a hidden part of us to free.

Our creative impulse, though it may be suppressed, never dies. It simply lies dormant and undirected, waiting like a desert flower for an opportunity one day to spring back to life.

If someone you know — perhaps even you — has used this myth as an excuse not to pursue the arts, the jig is up.

❖ ART POWER ❖

We strive to improve the quality of our lives in many ways. In our society, possessions are symbols of this quality and we continually try to replace them with finer ones. We climb one step to the next, each more expensive than the one before, each acquisition more aesthetic than the last, made of better materials with more skilled workmanship. Many of us play this game for an entire lifetime, attempting to ascend to the rarefied heights of owning a Ferrari, an original Monet, or a house designed by Frank Lloyd Wright — the supreme symbols of success.

This entire symbolic ladder is composed of products designed by artists. When we speak of raising the quality of life, we're saying, "I would like to own works produced or designed by renowned artists."

Yet most of us know little or nothing about how to create artistically, the source of all these rewards. We thrive on aesthetics yet choose to stay ignorant of the subject. We remain spectators and collectors without any idea of what we're missing.

A gold medal track winner at the Olympics was once asked why she ran. She said running gave her those rare moments when she felt suspended in time and space, without body, without mind, purely as herself. Such transcendent experiences probably occur more often in the arts than any-

where else, moments when our own spiritual beauty is revealed to us through creating our personal best.

Aesthetics is spiritual dynamite, particularly when you are the creator.

Talent and Creativity

What Is Talent?

"I'm not very creative. I have no talent." How often have you heard those words? Have you ever uttered them? People confuse creativity with talent. Talent and creativity are both important. They combine to create art, but they are not the same.

Talent implies a degree of skill. We use skill to build a creative idea into the real world for all to experience. The painter observes a spectacular view. By adding his creativeness, he imagines a splendid painting of the view in vibrant colors. Then, using his talent, he transforms his creative idea into the actual painting. The trained singer conceives a thrilling high note, and through training, she gains the skill necessary to reach it and hold her audience spellbound. The poet finds exactly the right words to evoke the magical images he wants his readers to picture.

Aside from talent or the lack of it, each of us possesses a well of potential creativity which springs from our world of thought. We all can originate a creative idea nearly instantaneously, from a chord struck by a

new observation, perspective or awareness. More ideas enter, until an entire creation is born with a magical life of its own. You simply create it in your own world of thought.

Incidentally, you won't find *creativity* defined in any dictionary as meaning you must come up with an earthshakingly brand new idea, one that is wild and shocking. It simply means being creative — having the ability to create. *To create* means to cause to be, to bring into being, to make. That is all creativity means. This creativity lies imprisoned within all of us. We have only to free it

The major obstacle to freeing creativity is our tendency to agree too much with the opinions of others. To be an artist, you must maintain your own point of view. Perhaps the main reason that many professional artists appear to be nonconformists and even revolutionaries is their instinctive reliance on their own points of view even when they conflict with the majority's.

This is not to say an artist should be completely blind to someone's opinion. The reactions of a trained and perceptive audience can help any artist judge the success of his work and find ways to improve it. A brilliant cast can transform a mediocre play into a wonderful evening at the theater — and show the playwright how to do a better job next time. The input of another is sometimes just the thing needed by a painter or composer in difficulty. But ultimately you must do your own thinking.

All great artists have successfully united their talents and originality into ideal action. Their greatness comes from having established a unique style and acquiring the disciplines needed to express their creativity through talent.

The important thing to remember is this: you are an original. You have originality. You may or may not have been born with an abundance of talent, but you certainly were born with a vast potential of creativity.

As an aside, from art form to art form, history is marked with a lack of balanced emphasis between talent and creativity. Some centuries had more attention on talent, others had more attention on creativity, and a few had equal attention on both. The latter always produced the greatest works of art. The past century, in my opinion, has put far too much attention on creativity and not enough on talent.

NATURAL TALENT IS NEVER ENOUGH

Those born with natural talent — say an instinct for color or the ability to sketch a good likeness — are often thought of as the chosen few. In the testing grounds of life, though, innate ability often turns out to be more of a liability than an asset. Natural talent enables one to do something some of the time but not all of the time. Because the natural hasn't a clue how he does what he does, he can't call on his abilities when he needs them.

I once had a peculiar little gift, nothing to do with art but a gift nonetheless. Though wary and largely

ignorant of things mechanical, I could start stalled cars. I'd amble over to the frustrated driver and, after nonchalantly clearing my throat I'd say, "Need a little help?" After some cussing he'd hand me the key. I'd put it in the ignition, turn it and, presto, the car would start. How did I do this? I had no idea. I simply knew I could, and I impressed everybody. I started about a dozen cars until a day came when one didn't start. That was the last time I tried to start someone else's car.

Natural talent, devoid of understanding, can fly the coop. One small failure can easily shatter it. Unable to feel responsible for something out of their control, the naturally talented can eventually invent all kinds of strange reasons to explain why they can only perform some of the time. Here's the writer who must drink to create his best lines, the musician who grooves only when he's high, the singer who thinks her voice is best when the moon is full, and the painter who "knows" he can only work when Mars is transiting Sagittarius.

Remember those artistically gifted kids from your school days? Have you ever found out what happened to them? I'll bet many never continued developing their talents, not even for themselves, and very few entered the fine arts.

Natural talent confers license. Why not? These lucky few are "special." In high school I was allowed to miss many an English or math class to paint the sets for the school play. But when highly talented

youngsters continue on to an art school, they get a rude awakening. The days of being the big fish in the little pond are over. They find themselves in a large sea, surrounded by many gifted youngsters. The shock is traumatic.

Raw natural gifts must be refined with study and training before they become truly valuable. An artist must be in control of what he does. He can't bumble through, hoping somehow it will come out right. The knowledge to gain artistic control exists, but the thought of seeking help is often impossible for the talented. For too long they have cashed in on the talent myth, using their gifts to impress others, to now squeeze their swollen but fragile egos through an art class door. Even when they do seek instruction, people with natural gifts sometimes find the going rougher than those new to the field; bad habits, unworkable ideas, and missing basics commonly plague the talented.

ORIGINALITY

The idea that you can originate simply because you want to is out of step with much of today's thinking. Based upon that thinking, Beethoven's Fifth would have to have come from a hammer hitting a knee — mere stimulus-response. Does it make sense that all our actions, thoughts and creativity are reactions and, therefore, must stem from a prior effect — and that prior effect from another before, and so on?

In other words, that we have no self-determinism and so no one really originates anything? I wonder what da Vinci and Rembrandt and the rest would say to this modern-day wisdom.

One hardly needs a Pavlov to know that people react to many things, particularly pain. Who doesn't realize that sometimes we all act like puppets, out of our own control? But this is not all there is to us. We can express as ourselves, and we can create — not reactively but simply because we choose to.

Originality is the power to originate — to cause something to come into being just because you decide to. New ideas that spring from your own self-created world of thought are original. We all can originate ideas. In other words, we all can create. Although a completed work is called an original, for the artist the finished work is only an attempt to recreate in the physical world what he first originated in his world of thought. Success is measured by the degree to which a completed work creates effects that match those envisioned by the original idea.

The great masters knew this. That is why they undertook their work only after thorough planning and study after study. Actors know this — they rehearse and rehearse again, striving for a creation that measures up to their highest standards. So do musicians.

Robert Henri, the great American artist and teacher, told his painting students, "Don't worry about your originality. You could not get rid of it

even if you wanted to. It will stick to you and show you up for better or worse in spite of all you or anyone else can do."

A true artists seeks to duplicate what he has envisioned in the real world. His satisfaction lies in how closely he can make his work approximate his original plan, and he accomplishes this through his talents.

❖ THE CREATIVE FLAME ❖

Years ago I lived and painted in a studio on a mountain overlooking one of the most breathtakingly beautiful scenes in the world. Islands dotted hundreds of miles of sparkling ocean before me. Below, a towering palm grove backed a mile-long white sandy beach. Each day I would sit for a while and watch the fascinating changes of the sky.

I never thought a day could go by without my noticing this splendor. But one day I suddenly became aware of it again after not having noticed it for years.

We tend to forget the beauty in our lives, the things we really admire. We can so easily lose ourselves in the perpetual motion of life and become so entangled in it that we no longer see the beauty that surrounds us.

When was the last time you really noticed the world around you? We take so much for granted—even the roads, cars, planes and boats, the mobility that allows us to travel anywhere in hours. Have a good look our buildings, our shopping galleries and offices, our supermarkets with half the world's products at our fingertips. Really see the electronic devices that bring us conveniences of every kind and entertainment twenty-four hours a day. Look how much we've created on a planet once barren of all but vegetation.

Too easily we turn a blind eye to our greatest

asset—our ability to create.

A creative idea is like a spark that ignites in our secret world. At first it might be just a flickering of an idea, but when fueled by the desire to make it grow into something more, it burns brightly.

As artist or potential artist, you never exhaust your urge to create. Once you open the dam, a never-ending stream of ideas will flow, each different and each a new challenge.

CHAPTER THREE

TRADITIONS OF EXCELLENCE

THE MEANING OF ART

To succeed in an artistic pursuit, one first needs to know, without any confusion, exactly what art is. In other words, what makes something art? To find out, let's see where the word *art* originated.

Art stems from *ars*, an ancient Sanskrit word meaning "to fit together" or "to put together." Later in Latin, the word *artis* meant "skill."

Skill is an ability to do something well, gained through knowledge and practice. To fit together or to put together means to plan and assemble various pieces by joining them in proper relationships into a unified whole.

Let's apply these meanings to the art of cooking. A fine chef, in the preparation of a particular dish, sifts through his knowledge, plans what to do, then uses his skills to fit everything together, using the right amount of each ingredient. While doing this, he adds his own creative touch and — voilà! — a gourmet meal.

But another vital ingredient is needed for it to be art: you — the one who experiences his cooking. The

sole criterion for art, from your point of view, is your opinion of its excellence.

Let's say you had a wonderful meal in a new restaurant — so delicious, in fact, you sent your compliments to the chef and made reservations to dine there again in a week. When you returned, you ordered the same dish and eagerly anticipated the meal. But when it came, the food looked awful and tasted worse. You complained and found that the previous week's chef had taken another job.

The difference lay in how well each meal was prepared and in your opinion of them. In a simple way, these two dining experiences illustrate the real meaning of art.

Deciding what is or isn't art rests solely with you. You cannot depend upon the opinions of art critics and friends. Can someone else respond emotionally for you? Would you ask someone to tell you which of the two meals tasted better?

There is nothing mathematical about art, no formula to give us proof. A "Wow!" or "That's beautiful!" is about the best proof there is.

One of the more delightful realities of existence is that we are all different — a fact which gives life color, diversity and vitality. We have different tastes. Who responds to things exactly as you do? Who is affected in the same way by beauty?

When several people respond favorably to an artist's work, he has a good start. When thousands are overwhelmingly in accord, we get a renowned artist.

However, there will always be those who believe otherwise. No artist, no matter how great, has ever pleased everyone.

We do, of course, have many tastes in common, developed through shared cultures and backgrounds. Some preferences we have grow naturally through observation of our environments, others result from traditions in the arts, and yet others have been incessantly drilled into us. There is, for instance, that idealized woman used every day in thousands of advertisements in an attempt to sell us everything from jeans to septic tanks. In earlier times, today's models would have been considered anemic — particularly to such great painters as Rubens or Fragonard.

The clearest definition of *Art* I have come across is this one by L. Ron Hubbard:

"ART is a word which summarizes THE QUALITY OF COMMUNICATION."

So, in its broadest sense, you can apply the word *art* to many activities. How good is the work of your doctor, your accountant, your hairdresser? Is it of high quality? How beautiful is the styling of your car, home or clothes? Are the things you do appreciated and admired by others? Do people see high quality in your work?

Art is the yardstick by which we measure all else. The lyrics from the old song, "It ain't what you do, it's the way that you do it," nearly says it all.

Art makes its presence felt whenever and wherever skill combines with merit. It doesn't matter what the

activity is. Art encourages pride in a job well done. It represents a love for one's work. It expresses the best there is in humanity. Art is the pursuit of excellence in all of our accomplishments.

THE FINE ARTS

When speaking of the fine arts, we usually refer to the visual arts of drawing, painting and sculpture. The fine arts also include architecture, drama, music, dance and literature. They generally consist of art where *the creation of beauty takes precedence over function*. Using this definition, one could also include some outstanding examples of photography, film-making and other art forms.

You don't have to originate a totally new and different idea to be considered a great fine artist. If you did, the finest actors, musicians, dancers and singers would not be fine artists, and only composers, playwrights and trendsetters in painting and sculpture would fill the bill. Interpreters of creations originally done by others can also be fine artists.

Fine artists strive to be the finest communicators and the prime movers of human emotion, to perfectly express themselves and cause profound effects upon others. Only the media and methods differ. Dancers use their bodies, musicians make sounds, and poets weave words.

The goal is to create an emotional impact upon others by way of artistic excellence. You achieve this

by developing the talents needed to freely and expertly express yourself. The truest aim is to put forth perfect musical, verbal, or visual statements and imbue them with your own feelings, sensitivities, nuances and creative differences — all to give others a transforming experience. Consequently, all great fine art is easily understood — though not necessarily in the same way by everyone. It needs no explanation or interpretation.

An unclear or badly stated message falls short of the goal of fine art. A singer might have a wonderful quality, but if she misses a few notes, she mars the entire listening experience. If I paint a child with the head a trifle too big, it can disturb the viewer rather than move him. One jarring line in a play can ruin the effect of an entire act. Attention always snags on blatant errors or disharmonious parts.

Everything has to be clear, harmonious and unified to allow attention to land unobstructed on the beauty of performance or execution. Clarity allows aesthetics to manifest in a work of fine art. I believe that all training and acquisition of talent and the understanding that goes with talent should have this clarity and perfection of communication as a goal.

In today's contemporary art world, many people have the mistaken notion that what makes a work meaningful is what the artist is saying — that in order for a work to be really creative, the artist must promote some significant statement, one that even shocks and creates controversy. For this reason, in

recent years, some dictionaries have added "intellectual stimulation" as another definition of fine art.

I submit that those responsible for the added definition have a confusion on the subject of fine art. Fine art has never had an essential aim to be intellectually stimulating or to make political or social statements or to promote sexual oddities. Of course artists have something to say but the message isn't why it is good or bad art. You determine the quality of a work by the emotional impact it has on you. The message is a vehicle to imbue with beauty.

The primary reason abstract art has never been broadly accepted is not, in my opinion, ignorance, as some assert. It is that the artist's message is not readily understandable. It's hard to be aesthetically and emotionally moved when you're busy trying to analyze a work while experiencing it. If you have to do this, it doesn't meet the criteria for fine art. So the next time you hear "What the artist means is _____" and can't make heads or tails of what follows, don't feel left out.

A great poet can write four simple lines about a leaf and evoke tears in a reader. He chooses his words and arranges them in such a beautiful way that they cause the reader to create images and experience his own emotions—all planned for by the artist in advance. But the words are about a simple leaf, something we are all familiar with. We don't get hung up on what a leaf is or stands for while reading the poem.

It's true that artists must introduce a few jolts into their work to keep an audience's attention. But there are limits to the jolts. The skill of execution in addition to the message is what makes it art.

The entire purpose of a fine artist is to become so skillful at conveying any message that he or she can concentrate fully on endowing it with beauty. The artist performs from the vantage of talent and self-expression. The viewer responds emotionally to the clear intention of the artist. *This* is fine art.

It Takes Two

A laughable modern idea has crept into the fields of fine art that a real artist creates only for himself. Imagine an actor spending a lifetime performing for himself in front of a mirror. All art requires an artist and a viewer, a writer and a reader, an architect and an inhabitant, a play and an audience. Art is in the eyes of the beholder as much as in the hands of the artist.

The magic of Beethoven stimulates the classical music-lover to create emotion-filled images. Though a sculptor chisels a figure in hard marble, we can sense soft skin. A fine artist does more than share his creations with others: he appeals to their individual creativity and invites them to create along with him.

And so fine art is a mutual creation planned, begun and executed by an artist and then completed by an audience.

PUZZLES

One could describe a great work of fine art as a puzzle where the pieces beautifully fit together. The great impressionist painter Paul Cézanne would sometimes spend fifteen minutes contemplating each move between brush strokes just to make one small part fit perfectly with the others.

When a painting is near completion, painters know their every move has to carefully harmonize with all others. Everything must fit together as one. This is the architect's dream: all elements of a building must work as parts of a larger, harmonious whole, including the natural setting in which it sits. The poet does this with words, the ballerina with positions and movements.

The solution to the puzzle, rather than the puzzle itself, is what makes every fine artist different. Shakespeare created the puzzle of *Macbeth* hundreds of years ago, but the ardent theatergoer always finds the experience different and refreshingly new — not because the story is different, but because each director and actor interprets it differently and endows it with special qualities. Many poets have glorified love and many more will, but each does it differently. Countless painters have tackled the puzzle of the female figure, and yet each canvas is unique because the artist solved the puzzle in a different way.

Fine artists take aim at people's emotions. The goal is to stimulate feelings in people, to rouse and

awaken new awareness and heighten perceptions of beauty. Creation of these effects defines excellence in the fine arts.

Why are the fine arts so powerful and fulfilling? Primarily because a fine artist induces his audiences to create along with him. Both the inventor of the puzzle and the audience fit the pieces together to complete the creation. In a landscape, a few brush strokes can become a distant forest. Good painters never paint it all. They encourage the audience to paint the details in the mind's eye. Good poets never write it all. They have the reader fill in the blanks, and complete their puzzle.

❊ AESTHETICS ❊

Aesthetics — our concept of beauty — is found in territory above and outside the meaning of things in the physical world. Aesthetics transcends analytical thought. When we apply facts, our yardstick for science, to aesthetics, we go wandering in the wilderness.

This explains why you may see someone not terribly bright about surviving yet a wonder as an artist. On the other hand, many highly intelligent people have little real understanding of — and therefore little interest in — aesthetics or art.

The key to understanding aesthetics is form, not meaning. Aesthetics is based solely on how various parts of a work of fine art, be they dabs of colors or notes of music or the sounds of words, are arranged in relation to one another. These arrangements, when in harmony with an individual's concepts of beauty, create an aesthetic experience.

Stand barefoot on the water's edge at sunset. Take in the vast, moving ocean, the luminous red sun, the rolling clouds, the fine shades of yellows, oranges, reds and blues in the gradually deepening sky, the sounds of the waves pounding the shore, the movement of cool water as it caresses your toes, and the shifting sand under your feet.

All aesthetic experiences are created by finely tuned harmonies of elements which strike our senses and cause us to respond emotionally.

CHAPTER FOUR

THE ARTIST

THE BRIDGE BETWEEN WORLDS

There are two truths on which we can all agree. One is that we live together in the material world; the other is that each of us possesses our own world of thought — call it the mind, the spiritual, call it anything you like. Each of us perceives both worlds.

We each have a sense of self and personality distinct from all others. We are individuals. We can be aware of ourselves, that we exist, and of what we think and do. And we can create.

All creations begin in the world of thought. It is miraculous when you think about it. We simply decide to create something in our private world — and there it is. But then, how does one cause what one visualizes to manifest in the material world for everyone else to see?

It doesn't take talent to visualize something, but to bring it into the material world takes loads of it. This is where ability or skill — talent — comes in.

Talent forms the bridge between the two worlds.

The First Three Steps

Let us first examine the actual steps taken to create in our world of thought. Can they be isolated and understood? The answer is yes.

Creating in the world of thought requires three separate steps:

1. Observing
2. Making decisions about what to create
3. Visualizing the result

I call these simply *the first three steps*. In any creative act, be it cooking or painting a house, first we observe the area of interest to determine what is available and what is possible, and then we decide exactly what we want to end up with. Then, if we are smart, we picture it as if it were already done.

In addition to using the first three steps to conceive of a creation, we use them again and again as we put our talents to work building our private creation in the physical world for others to see. While painting, an astute painter observes, decides exactly what he wants, and visualizes it done for each action he takes along the way. He makes every brushstroke in the world of thought before he puts it on the canvas.

Observing

Robert Henri, a great American painter and teacher, once said, "It is harder to see than it is to express." The success of a painting rests on an artist's

ability *to see as a painter*. Painters learn to see differently than other people. They look for the form and colors that visually make up an object. You could have highly developed skills, but if you couldn't break a subject down into its visual components, your talents would be meaningless. In other words, a painter has to observe with the express purpose of producing an illusion of something on canvas.

For example, to help create the illusion of three dimensions on a two-dimensional canvas, a knowledgeable painter observes his subject matter by way of a visual trick: he squints his eyes. By viewing the subject with eyes almost closed, an artist can more clearly perceive and distinguish the various shapes of light and dark areas. Creating these different lights and darks gives a picture a sense of depth and space. Everywhere we look, from a midnight-dark sky to a sun-dappled field, we will see lighter and darker areas. Squinting is a trick painters have used for centuries.

With good instruction, a student will have changes in perception. These milestones enable one to notice things not seen before. A musician can have dexterous fingers, but more importantly he must have a good ear. In addition to agility and grace, a dancer must have highly developed perceptions of space and motion.

In the course of artistic training, a student will sometimes suddenly move to a permanently higher level of perception, and thus a higher level of observation and understanding of his or her art. By impor-

tant perceptual change I mean a new truth capable of realigning a great deal of other information in a more meaningful way.

A good creation is built upon the artist's not only seeing, but also understanding what he is seeing. An actor who understands his lines performs better than one who learns them by rote. A representational painter who understands the three-dimensional structure of his subject matter depicts it better than the painter who just copies what he sees.

This understanding is built through observation.

DECIDING

When creating a work of art, you can move in any direction at any time, but unless you decide exactly what to do, you'll find yourself either moving in all directions at once or not making any progress at all. You have to choose a direction. All competent artists plan their moves before making them.

There are two general areas of decision-making. The first area consists of all the decisions needed in order to get started, including those enabling you to get a fairly good idea of the finished product. This is where writers do outlines and painters do sketches. They choose directions. The more observations, the more understanding; the more understanding, the better the decisions.

The other general area consists of all of the hundreds and hundreds of decisions made while the work

is in progress. You don't build a work with hit-and-miss methods. You must decide upon each step before taking it. A professional keeps control of his work with decisions based upon sound observations each step of the way. True, many fine artists appear to produce their effects without thought, but they have years of experience behind them and can observe, decide and visualize almost instantaneously.

There are an infinite number of ways to do something. Your repertoire of styles, methods, sometimes materials, and your own expressiveness make up what is called technique. This holds true for all the arts.

What appeals to you? What are you saying? What effects are you attempting to cause for others? These types of questions lead to some of the decisions.

A dancer may wish to create the illusion of a world without gravity that will hold her audience spellbound. A poet may wish to show the music of language. One writer may want to evoke joy in his readers, another anger. In each case, creative decisions must align with the objective for the work.

One of the most difficult decisions to make is to throw away part of a work you feel is special. Artists are commonly faced with this problem. One should never become too attached to parts of an unfinished work. Always leave room for change. The original intent is what you strive for no matter what beautiful but unrelated byway may please you and tempt you to stray. If it's wrong, it has to go.

Artists make thousands of decisions. If the obser-vations are sound, so too will be the decisions.

VISUALIZING

The third step in the process of creating requires the use of an ability we all have but which many of us fail to utilize: the ability to visualize the outcome of an action before doing it.

Successful people from all walks of life visualize the results of their actions before taking them. Before the race has even started, a track star pictures himself flashing across the finish line. In the split second before it leaves his fingertips, a great basketball player sees the ball go through the hoop. A businesswoman observes the need for a certain product, makes her decisions about production and marketing, and pic-tures people all over the country enjoying its use.

The whole idea of visualizing is based upon this one simple yet immensely powerful idea: if you can make something real for yourself, you can make it real for others. If you create it in your mind, then you stand a chance at creating it in the material world.

A young woman I know who wanted to become a country music star had a dream to play and sing at the Hollywood Bowl. Although she had the talent to succeed, when I asked her to picture herself all decked out on that huge glowing stage before thou-sands and thousands of fans, all applauding and screaming for her to begin her performance, she

couldn't do it. It was too much for her to visualize, and she'd never have succeeded. But she could visualize herself in a small club singing to a dozen people—and that's how her career started.

Visualizing success as an existing reality—not seeing it as something that may happen in the future but as something that is happening now—is vital to success. Even when you do it in your own universe of thought, you feel better and grow stronger. It inspires you to continue toward the goal because it is now more real, clearer, and better understood.

If you have difficulty visualizing something, you haven't made enough decisions about it or it could be too large a project for you to handle. If making decisions is the difficulty, you need to observe more. If it's too large a project, start with something smaller.

If you don't know your destination, it's impossible to know when you've arrived, or even if you're getting closer. You'll know, however, if you first visualize where you're going.

❖ ART AND LONGEVITY ❖

When people unblock their creativity and begin to grow as artists, they become happier, healthier, and enjoy longer lives.

I have seen it time and time again — people who have long suppressed their creative urges then suddenly release them experience a feeling of well-being and a tremendous sense of relief that they can attain their dreams in art.

Most people sleep more than necessary to dull the tedium of an unexciting life. Why bother to get out of bed if you have nothing to look forward to?

But to wake up chomping at the bit to get going on something you really love is something else entirely. Whenever you've been enthusiastically involved in a rewarding activity, haven't you felt better, slept a little less and moved a little faster? You probably didn't think of eating as often either.

Artists sleep less and dream more. They create and live in a magical world of games with endless puzzles and exquisite solutions.

Art's goals are endless. When an artistic endeavor is finished, one realizes another is on the horizon. The creative process has its own kind of excitement and people involved in it usually admit there is nothing they would rather be doing.

Artists seem to live longer — from Eubie Blake, who saw his 100th birthday, to Arthur Rubenstein, playing Chopin in his 90's, to Matisse and Picasso,

who lived past 90. The great Renaissance painter Titian painted some of his masterpieces at 99. Even those in discomfort or pain don't let it deter them. Henri Matisse, flat on his back in a hospital bed, taped a stick of charcoal to a long pole and kept on drawing. Nothing stopped him.

Winston Churchill turned to painting when he was forty. He called it an "astonishing and enriching experience." He said, "Happy are the painters for they shall not be lonely. Light and color, peace and hope, will keep them company to the end, or almost to the end, of the day. Painting is a companion with whom one may hope to walk a great part of life's journey." And he did—into his nineties.

The Fundamentals of Fine Art

The Pyramid of Knowledge

The most vital information about any subject is the fundamental knowledge upon which all else rests. Just as building a house takes knowledge, so does building a work of art. Originality of design comes from creativeness, skill in execution comes from talent, but the how of building fine art comes from understanding. Talent is truly valuable only when an artist really understands how and why he does what he does. This understanding is based not upon whim or flair but upon actual knowledge.

When a subject is properly laid out in the correct sequence of importance, details come last. By knowing the most basic knowledge common to all the fine arts and then the basics of the particular art form, anyone can begin to approach personal excellence.

Artistic knowledge forms a pyramid structured on the idea that the most fundamental knowledge should lie underneath and be learned first; the simplest concepts always support the complex ones. Although the top of the pyramid holds many fascinating bits of

information, none of them will be of any use without the bottom and intermediary sections firmly in place.

The most fundamental knowledge of all, the root meaning of the word *art*—"to fit together"—forms the base of the pyramid. All else derives from it.

Next come basic principles that are common to the creation of all fine art. Clearly understanding these can drastically cut the time it takes to acquire talent.

Then comes acquiring the basic skills of a particular fine art form. Once you have these in place, you can learn the more sophisticated skills by studying the work of great artists.

A pyramid of knowledge can be built for each fine art form, but the arrangement of the contents is similar for all.

THE THREE BASIC PRINCIPLES

Three basic working principles conjoin in the building of any piece of fine art, be it a painting, a building or a poem. These three principles could be considered tools, but they are more. They are the very essence of how best to create any work.

1. Relate parts to one another and to the whole.
2. Work from large to small.
3. Cycle throughout the whole work.

The three principles have been stated through the centuries in different words. They work! They always have and always will. Their use causes a work to align and become powerful as well as beautiful.

I have found these three principles to be the most reliable and sanest way to create art. Not only do they constitute a solid, reliable building process, but their use expands originality, and creativity flourishes within their framework. These three basic working principles make up the second section of the pyramid of knowledge for all fine art forms.

THE BASIC CONCEPT: RELATING PARTS

The process of building relationships among parts is the senior basic working principle of fine art. For this reason I call it the *Basic Concept*. All complex creations—a musical composition, a book, a painting, a ballet or a building—are made up of many pieces or parts. Each piece or part must play its correct role with the others, and how well they all fit together determines the success of any work.

In relating one part to another and to other parts, and then to the whole, the artist applies the broadest root meaning of art—skill at fitting together. The types of parts vary from art form to art form. In music, there are notes, chords, timed beats, rests, etc. Painters choose lines, shapes, tones (degrees of lightness and darkness), and colors.

In a masterpiece, every part of the painting is purposefully constructed and positioned to fit perfectly. A fine painter works by distilling, comparing, deliberating and finding connections he thinks important—and the only reason one part is more important than another is that he decides so.

The biggest misunderstanding for someone new to drawing and painting is the idea that you simply reproduce piece by piece what is in front of you. That is not creating, it is copying.

Creating involves you, not just what you see. In drawing and painting, scanning your attention from place to place as you work provides the means to observe how the parts relate to one another. Expanding and contracting the scope of what you take in gives you the ability to build relationships within the unity of the whole. First you see a part, then you expand your point of view to see how the part fits in with other parts, then how they all relate to the whole — then contract your scope again to work on the part or its immediate surroundings. You don't work exclusively on one part and then forget all about it while doing the next.

Using the Basic Concept of relating takes practice. The biggest problem you'll have in relating parts is getting used to doing it. Most people aren't accustomed to thinking and building like this. Because, in life, we normally focus on one thing at a time, the technique takes a strong conscious effort, especially at first.

When you create art, you must see the consequences of each action you take relative to other parts and the whole. In music, for instance, you can make something sound soft by making the note or chord just before it loud. You can make an area on a painting appear lighter by making something next to it darker. Using just the right word in a poem can unify

several ideas into a single overall concept. In this way, an accomplished fine artist makes magic.

WORKING FROM LARGE TO SMALL

Most school children learn to outline a composition before writing it. This is an example of working from large to small. First organize and execute the largest elements, making them work well with one another before getting into detail. You don't waste time refining when the large parts don't mesh properly.

Working from large to small means going from general to detailed, from important to less important, from simple to complex. If you take the time in the beginning to properly relate the larger, essential elements, and then gradually refine the work, everything falls into place and it almost finishes itself.

Working from large to small is inescapable in some art forms. A marble sculptor has to remove large pieces first. You can't sculpt a nostril without first getting to the nose. A novelist will generally outline the broad idea of his plot and characters, then zero in on details and expand them. Don't become infatuated by the small — the exact color of an eye in a portrait — before addressing the large elements, such as the position of the body and then the head within the confines of the canvas.

Working from large to small goes hand in hand with relating parts, but is slightly junior in importance because it too involves the Basic Concept of relating.

Cycling Throughout the Whole Work

Suppose you were planting a garden and wanted to fill it with your favorite vegetables. Would you plant tomatoes, water them daily, nurture them and put all your energy into them until they were fully grown — and then, and only then, plant the lettuce and do the same for it? Of course not. By the time the lettuce grew, the tomatoes would be long gone, and the garden would never be filled with a variety of vegetables. Likewise, a builder doesn't lay out a house, pour the foundation and then build an entire bathroom complete with tile, faucets, and towel holders before framing the whole house and putting in the electrical and plumbing throughout.

The third basic working principle is always to cycle throughout your entire creation as you are building it. This means continuously moving about the whole work, creating first here, then there. It also means working in stages, completing each before starting the next.

The main difficulty with cycling throughout is that certain pieces are more fascinating or more fun to work on than others. A writer can love one of his characters and be lukewarm about the others. A painter can be so smitten by the beauty of the roses that he neglects the vase.

Just as a mother shouldn't favor one of her children over the others, neither should the artist favor

any single part of his work. Each element plays its own role and helps the others. A fine artist has to be responsible for every part of a creation.

By continually cycling throughout, working on all the parts equally, you achieve balance and harmony in your art.

◈ THE STREAM OF TRUTH ◈

Above the methods of working I've described stands intuitive creating—the ideal method of attaining artistic perfection. Working intuitively requires no complicated reasoning at all. You just know what to do.

By far the most creative and fruitful moments for any artist are those when his work simply flows from him. It all happens effortlessly. This is the most exhilarating and powerful stream of truth anyone can revel in. Many artists have experienced this phenomenon; more have not. It doesn't happen often, but when it does, all the efforts are worth it.

Everyone is intuitive. Intuition is based upon one's certainty of perceptions. We all have moments when we know simply because we know. There is no reason or explanation. We are capable of knowing—just knowing. Unfortunately, we cannot always depend upon intuition to be there when we need it.

Everyone has experienced this ability in some way. Knowing something when it was physically impossible to know it. Knowing a place that you had never been to before in this life. Knowing exactly what someone else was thinking. Knowing when you should leave—or stay. Knowing the future. These metaphysical awarenesses are based only upon one's perceptions. No analyzing in the

world can ever figure them out.

Sometimes when an artist is working and everything is right, the intuitive creative flow just happens. For a poet, the exact words spill out and the poem writes itself. The painter knows without thought each move before doing it.

Recognizing your intuition and putting more faith in it will give it more reason to be there to guide you.

AN ARTIST'S STRENGTH

THE DISCIPLINE PROCESS

So far we've covered the theory of creating and how fine artists use talent as a bridge between their worlds of thought and the material world. You know the creative steps of observing, deciding, and visualizing, and the basic principles of relating parts, working from large to small, and cycling throughout the whole work. These are the most important ideas to making a dream a reality. Great in theory, you might say, but how do you actually employ these principles to produce art?

I teach my students to apply what I call the *Discipline Process*. This process unites the basic principles and ideas into a unified, easy-to-use method of working.

The Discipline Process consists of six distinct steps:

1. Choose a basic working principle to govern your observations.
2. Observe.
3. Decide.
4. Visualize.

5. Do.

6. Correct what you did until it is right.

First, select one of the three basic working principles to govern the way in which you will observe the subject. From these observations, make exact decisions. Next, visualize the decisions as though already put into effect. Then, actually take whatever actions your decisions and visualizing call for. Finally, compare what you did to your visualization of it, and make any necessary corrections until they match.

Having done what you intended ends one time through the process. Now repeat these same six steps over and over as you work, from the beginning of a painting until the end. You can use any of the three principles to govern your observations at any time, switching to a different one when you return to the first step, or repeating the same one several times. The Discipline Process keeps you in complete control of your work.

To further illustrate the use of the Discipline Process, let's say you've selected the principle of working from large to small. You would then observe your subject, looking for a few large, simple shapes within it with which to begin. Next comes making the exact decisions on what shapes to paint, how to paint them and what they should look like. Visualize them already done on the canvas. Only after doing all that would you actually touch brush to canvas and paint in the shapes. When finished, compare them to what you visualized, see if anything needs to be corrected,

and do so. Once completely satisfied with what you did, continue the work by repeating the six steps.

The Discipline Process does not restrict an artist; on the contrary, it frees him and greatly enhances his creativeness. The only problem is, it takes discipline.

Discipline has gotten a lot of bad press. Young people especially seem to shudder at the mere mention of the word. To most people it has come to mean punishment. But what I mean by discipline is its primary dictionary definition — to train the mind and character.

Recently, our permissive "feel good" thinking, disregarding adequate judgment, has led us to mediocrity and vastly lower standards of personal excellence — in part by presenting the idea of discipline as an abomination. But if one doesn't discipline himself, life eventually will.

How often have you driven your car while daydreaming or thinking of other things and then not remembered how you arrived at your destination? Maybe you can get away with driving by habit, but you can't truly create anything from habit. Habits don't produce originals, they only make copies.

Likewise, an artist can't apply the Discipline Process automatically. It can't be trained into anyone to become second nature. It has to be applied consciously. Creating fine art demands willpower, concentration, and self-discipline. You have to *be there* to create.

The Discipline Process enables you to remain the creator. To be the true source of the creation, an artist

must take charge of every large part and every small detail. Each must pass through his private world of thought before becoming part of the work.

Although the Discipline Process takes some getting used to, the amount of progress made on a work using the process compared to working haphazardly will make you a convert. Unthinking, unplanned moves always lead to frustration and wasted motion. The Discipline Process leads to ever-widening certainty and control over your work. Your creativeness soars.

UNITY, SIMPLICITY, AND HARMONY

Three other concepts — unity, simplicity, and harmony — create a pathway to excellence and lead to artistic perfection. An interesting parallel exists between these three concepts and the three basic working principles. All fine artists strive first for unity. Unity means combining all the parts into a unified whole. This action parallels building relationships among the parts.

In solving the puzzle of beauty, a fine artist forms his work into a whole that functions as a single powerful unit of expression in which all the pieces fit perfectly together. The magic of a master resides in how he puts together his puzzles of sound, sight, motion or words. His mastery comes from the enormously high degree to which parts concur to form a whole. A masterpiece is a perfect union of elements, the epitome of unity.

Simplicity parallels the principle of working from large to small. It creates a purity of expression, free from overindulgence of embellishment or detail. It promotes clarity and sincerity. It keeps you from going overboard and saying too much. Simplicity is the enemy of boredom, irrelevance, verbosity and excessive length. It keeps art from becoming an ordeal.

Harmony — a pleasing arrangement of the parts — contributes to unity in a work of art just as unity creates a degree of harmony by virtue of the fact that parts can fit together in a variety of ways. The principle of cycling throughout the whole work is the pathway to harmony.

Harmony consists of more than just different elements agreeing with one another. It is deeper and more essential. Harmony gives a feeling of accord, a pleasing sensation that all the parts fit correctly and therefore function well together — as if the work is in tune with itself and with us. A fine artist finds harmonies to play with while perfecting his work, striking chords in words, sounds, colors, and/or motions. He then repeats or modifies these chords, reducing or increasing them in size and scope. He alters the spatial relationships of the parts to create desired effects. Rhythms form and in turn harmonize with one another.

Cycling throughout creates harmony within the work, and harmony helps create aesthetic impact. The painter places a dab of soft red over here and one there and another a little further down. He uses a

hint of it on the dress and a tint in the skin tones of the portrait. Some are meant to be noticed, others only to be sensed. The game is to blend all these elements and hundreds more, with each brush stroke, into one wondrous overall effect.

Applying these three concepts — unity, simplicity and harmony — can lead you to the richest rewards of art.

❖ OUR DREAMS CREATE ❖ OUR FUTURE

The science fiction writers of the nineteen twenties and thirties, artists all of them, wrote about spaceships, rockets and the like before scientists began to develop ways to actually accomplish space flight. Leonardo da Vinci dreamed of machines that flew. H.G. Wells saw a future that seemed pure fantasy to those who lived in his time. Artists dream first and then express their visions through their art forms. Only then do practitioners of the material universe who believe in the artist's vision begin to establish ways to make these dreams realities for us all. This has always been the way of the world.

Artists are the real inventors of civilizations. They write the scripts and create the sets that enable us to play at life. Artists are precious resources and should be treated as such.

Go to an art show or attend a concert. Look around. All those people buying the paintings or admiring the music — or indeed, people anywhere who buy the best of everything — are attempting to improve the quality of their lives by sharing the artist's experience and vision. Art is important to life, and people intuitively know this.

Our civilization evolves as art impinges on the status quo. Slowly — and in recent decades not so slowly — art advances civilization and changes it.

Today we live in the greatest time of change in human history. It's not by accident that the greatest changes in art have preceded the intensity of change we are now experiencing. Further exciting and unforeseen changes lie ahead.

Most people have too little creativity in their lives, but perhaps this condition is about to change.

Perhaps you feel you don't have the ability to greatly influence future events through the art you could produce. You might not even be interested in doing so. However, every aesthetic act is like a drop of rain that falls into the stream that leads to the river that thunders into the sea. All art has a way of contributing to the cultural ocean of humanity. Its effect upon our combined consciousness can be greater than you realize.

Beauty, in whatever forms it takes, can move the hearts of men.

Robert Henri said, "Art when really understood is the province of every human being. It is simply a question of doing things, anything, well. It is not an outside, extra thing. When the artist is alive in any person, whatever his kind of work may be, he becomes an inventive, searching, daring, self-expressing creature. The world would stagnate without him, and the world would be beautiful with him."

PART II

*Art when really
understood is the
province of every
human being.*
— Robert Henri

THE MAKING OF AN ARTIST

AN ARTIST'S ATTRIBUTES

Do you still feel a little intimidated by the thought of pursuing excellence in the art form of your choice? Do you doubt your ability to succeed? This is perfectly natural.

Perhaps it would help you to know that every successful artist, regardless of his field, needs only four attributes. You probably possess some of these already, and those you don't you can acquire.

Every successful artist has

1. A fascination and love for his or her art
2. The needed talents
3. The ability to be individually expressive
4. A desire for others to appreciate the effects he causes.

To do something well, you must like the activity. You don't find painters who would rather be fishing or watching TV. While they may enjoy reeling in a trout now and again, they get their greatest pleasures from the smell of linseed oil and the challenge of finding a way to create beautiful effects with a new

brush. You just don't succeed very well at anything not done out of love.

To do something well, you also need to have all the necessary talent under your belt. Excellence comes from being able to do. We learn to do best through a mixture of good instruction and on-the-job training. This is nothing more than the old apprentice method of years gone by. We learn step by step.

Years ago, Grandma could bake a different pie every week, each one good enough to knock your socks off. She didn't need recipes from dozens of cookbooks. She understood pie-making from the bottom up. She knew the way to finely sift flour and lots of tricks to brown a crust perfectly. She didn't take shortcuts. Great Grandma wouldn't let her.

People feel inept when they haven't acquired the basic skills to do something well. They don't realize that as you learn the correct basic skills, your certainty of doing rises, you begin to shed the false idea that it can't be done, and self-doubt drops away. When you know your basics, self-expression and excellence can blend and bloom. You then can develop your own style, your own individual way of expression.

Premature attempts to be overly original always lead to disaster. Anyone who has employed a rela-tively untrained person knows this. The tendency of the new person is to dream up quick solutions — usually ones that you yourself tried and discarded years before when you were starting out. It takes time to learn the ropes and attain the knowledge necessary

to function properly in any new activity. You can see this principle violated in the arts today.

An artist who is very interested in how others respond to his work—not the critics and gallery owners and producers and publishers, but the actual audience—wants it to affect them in a deep and lasting way. He wants them to have new awarenesses and sensations because of what he does. He wants them to create along with him, and he wants their admiration for his efforts.

People want others to appreciate their work, and it's only right to receive the acknowledgment one has earned. People don't continue to create unless, eventually, others begin to show their appreciation. Painters who accumulate their paintings by the dozen and never show them to anyone stop painting sooner or later. It's just a matter of time.

The attributes needed to succeed are plain to see and attainable. There is no mystery to the pursuit of excellence. All it takes is guts, persistence, the will to rise above mediocrity, and the desire to create the best you have to offer this world. Success is there for all who want it and are willing to do what it takes to get it.

VIVE LA DIFFERENCE

No two people are alike. While we should indeed have equal rights and opportunities, it's quite evident that we don't have equal abilities in all things.

As well, we all lead different lives with different

responsibilities. Don't be discouraged if you must attend to other obligations during your training in the arts, and don't be too hard on yourself because you continue to keep prior agreements. A person with children and other pressing duties may not be able to practice as much as someone who is young and single or who has just retired.

Most of us are accustomed to competitive education, which doesn't accommodate individual rates of learning. Faster students, forced to slow down, lose interest, while slower students stumble through their materials and often miss vital information. This kind of education fosters mediocrity, and it is no way to achieve excellence in the arts.

It's smart to plan ahead. I've taught hundreds of people who were preparing to retire or whose children were grown up or about to leave home. Those who started their instruction a few years beforehand were ready to fully enjoy the arts when the bonanza of free time arrived.

Young or old, you should simply begin. The arts are like flowers that grow from a bud and open as time goes by to give off more and more fragrance. The sooner you get started, the more time for the fragrance to develop and spread.

Differences between people dictate different pursuits. In painting, someone who is extremely quick might do better with watercolors, a fast medium, while the slower, more patient individual might succeed more easily with oils, where the pace can be

leisurely. People gravitate toward the medium or art form that best suits them as individuals. Don't be afraid to try more than one to find what's best for you, and don't worry too much about the future. If you know you have an affinity for a particular art form, go for it. Specific goals grow clearer as time progresses and you acquire skills.

The most effective way to attain excellence at something is through individual instruction. We all learn at different rates of speed. This applies to the assimilation of material as well as to its application — familiarizing ourselves with it, making it our own, and putting it into action. Our rates of learning vary from subject to subject; even within the same field some skills are easier for us to master than others.

I've seen hundreds of people begin artistic lives. Those who are slow at first, who take a lot of time to really learn the early fundamentals, usually speed up and learn as fast as the quick students. Most slowness comes from attitudes of uncertainty. "Can I really do this?" "I'm starting with so little talent." "Others are so fast." You must forget all these attitudes and real-ize that if you persist, you will succeed.

Some students, in fact, lose out by being in a hurry. Early periods of learning are the most important. Don't rush through the fundamentals or you'll regret it later. If you really understand and apply what you've learned, you'll continue to grow and go on to an enriching life in art. It is key to keep an actual rather than an emotional perspective on your progress.

Remember, you are different from others. You will learn differently, and what you ultimately do in your art will be different from what anyone else does. Individual self-expression gives art its infinite and unique faces.

Vive la difference.

WRONG IS RIGHT

As a rule, most people find it difficult to be wrong. In order to feel good about themselves, they insist on being right—even when wrong. This is the path away from excellence.

The artists who can be the most wrong are the great masters. They delight in being wrong because they know that it leads to perfection. They don't look for what is right while working, they look for everything wrong in order to constantly improve their creation.

In the beginning a student will desperately clutch to his bosom anything right about his work and flail himself mercilessly for anything and everything wrong. This is as truly wrong as you can get.

When an actress first reads a new script, she doesn't try to give a perfect performance. Getting it totally right requires readings and more readings and rehearsal after rehearsal. With every reading or rehearsal she corrects what was flawed with the previous one until she achieves perfection. This is true of all the fine arts. Speed is not important. Clarity and quality are. Excellence takes as long as it takes.

As people progress and gain the knowledge needed to correct their work and make it better, they learn it is not just okay to be wrong, but an asset. This type of thinking builds until there is neither false pride nor self-abasement, only a clear-eyed distinction between what works and what needs improvement.

The real mistake fine artists make is not to correct something wrong, or not to find out how to correct it before continuing. This is the exact point of any downfall for any artist or work. Never go on to the next step when you see something needs correction.

An artist should strive to reach the point where he can easily be wrong about any of his decisions without making less of himself. Everyone makes mistakes. It's part of the learning process. In fact, knowing what doesn't work is as important as knowing what does. We change as we learn. When we learn from mistakes, we win a little each time.

Be good to yourself. Know that the ability to be wrong without damaging yourself leads to personal excellence. This is not some trick of positive thinking. It's a fact of life.

COMMITMENTS

Artists can lose control of their work by committing too heavily too soon to one part of a work, a favorite technique, or even an "ism" to which they have attached themselves.

A heavy commitment is hard to erase, so the tendency is to keep on going, even when it's wrong.

Worse, a heavy commitment prevents you from see-ing what needs to be done. You think you already have the answer when you really haven't.

On the scale of a single work, if a novelist decides character X will murder character Z in the last chap-ter, and refuses to change his mind even when plot and character development no longer lead in that direction, the result will be a flawed novel. On a larger scale, Picasso in his youth helped invent cubism, but his commitment to it was tentative enough so that he could move on when he'd achieved his goals in the genre. Most artists who commit irrev-ocably to a school or technique at an early age never achieve success or quickly fade into obscurity.

Every artist who works alone really acts as a group, even if the members aren't clearly defined. This can become confusing. An author, for instance, is also the researcher, writer, editor, reader, and critic. He must remain aware of these different roles, when to play each one, and the pitfalls of committing too heavily to any one of them for too long.

A major reason the arts are so absorbing is the fre-quency of problems to solve and decisions to make. A painter exercises more decisions in one painting than he does in six months of normal life. Any con-tinuously creative activity requires hundreds of sepa-rate decisions to bring off a fully original piece. The ability to avoid premature commitment and to change one's mind is a vital part of an artist's deci-sion-making skills.

STICK TO IT

Make a firm commitment to persist in your artistic pursuit. This is an imperative step. The secret of gaining pleasure from your efforts as a student is to really *be* a student. A student is someone who desires to learn and who works at it through thick and thin.

Be realistic about your progress. Realize that the results you wish to attain won't happen overnight.

A poor student usually has a wrong mix of purposes. If you're too concerned about how your work compares to other students' or what you can take home to show off, you won't progress in that class. Know why you're receiving instruction. If each time you attend a lesson or class you learn something new and can apply it, you are on the correct path.

You become accomplished in the arts through good instruction and practice. Good instruction is an absolute necessity for increased perceptions, be they perceptions of color, form, musical notes, or the rhythm of words. Your instructor must be someone who can point out what you cannot yet perceive, both in the works of the masters and in your own.

Most people take several years to acquire the skills to excel at art. Some art forms call for daily practice in the beginning. Playing a musical instrument requires developing dexterity. Drawing, painting, sculpting, writing and acting, on the other hand, can be practiced at a more leisurely pace. But in all the fine arts, the more you put in, the more you get out.

There is a direct relationship between the amount of time spent learning and the speed of progress.

A trend forms over a period of time, a personal learning curve. Keep some record of past performance to help you see your progress. In music, you could tape your progress every few weeks or so. With drawing or painting, you could keep your student works and date them. This helps you remain fair to yourself.

All study has its difficult moments and everyone will encounter thickets along the path. However, there are several basic reasons for these snags.

1. You are being given incorrect technical data about your art, or none at all.
2. You are not being given the right instruction for the level you are on.
3. You misunderstand something about the instruction.
4. Someone is working against you to stop you from succeeding.

Just spotting which one of the above applies will help.

The wrong thing to do is give up your dream. Persist. Stick to it.

CRITIQUING

Without the intention to help, criticism is invalid. You should never take aimless criticism to heart. One of your responsibilities as a student is not to associate with people critical of your efforts. The only safe and

valid criticism comes from an instructor whom you trust completely. An instructor must be a critic; however, a good one will always impart the knowledge and skill needed to improve—which you can then apply to visible results.

Self-criticism too is destructive unless accompanied by a realization leading to improvement. By itself, it will surely drive you down to a less ambitious and effective level of work. There is quite a difference between putting yourself down and desiring to improve. The former reduces capabilities, the latter increases them.

All good teachers encourage a student to make his or her own decisions. You should be able to maintain your own viewpoint even while learning. Still, an artist must learn to acknowledge the viewpoint of another, whether favorable or not. Sometimes comments by a well-meaning person can help solve an artistic problem. This is not criticism just for the sake of criticism, but comes from an appreciation of your work, a desire to help and, perhaps, a knowledge of the art form.

Only the foolish seek approval from "authorities." One who does can become permanently sidetracked from his real dreams. When an artist indiscriminately sops up the evaluations and opinions of another simply because of some imagined status that person has, he ends up becoming a pawn in that person's artistic agenda. He sings their music, writes their words and paints their paintings. Viewing life or your art through another's eyes removes you from your own originality.

Originality doesn't thrive on what others think.

On the other hand, an artist should be able, without seeking it, to receive applause. Only then can he know the full value of his work.

An artist must keep his own point of view. It is his most precious asset, the seat of his creativeness. Be true to yourself.

SUPPORTERS

Your best friends are those who support you. They are the people who want you to fulfill your dream. You need them — perhaps more than you know. Find friends who support you and value them for their contribution. Help them to help you.

It isn't always easy to pursue excellence and follow your dream in this world. Nor is it always easy for others to deal with your quest. Understand that in wanting to accomplish your creative goals you are unlike most people. Your suddenly doing something different can upset people you thought were your friends. People aren't accustomed to seeing others actually try to change and improve their abilities; it can even make them feel bad for not doing so themselves. It takes courage and persistence on your part, particularly in the beginning when you don't have much to show for your efforts.

There are different ways to safeguard your dream from those who might not think you can succeed or don't want you to. One is not to seek support from

others. Another is to keep your quest to yourself until you feel more confident. Go to your classes or lessons and progress. If you must mention what you are doing, you will know soon enough from their reactions who's with you and who isn't.

If you're married and your partner is on your side, you have the best possible help you can have after a good teacher. Share your joy and include your partner in your pursuit wherever possible. I have taught painting to married couples. An entirely new mutual interest develops, and the shared activity adds a delightful dimension to the relationship. In some cases, friends have taken lessons as a group, and they now paint or go to museums together.

If you want something that's good for you, that adds happiness to your life and the lives of those around you, you will make the time for it. Most people close to you understand when you value your time and your goals, but perhaps not all. Don't allow yourself to be pulled off course by someone who "knows what's best for you" or wants your help with his goal to the detriment of yours.

Do not permit another's opinion or hidden intention to stop you or hold you back.

HAVE FUN

A lighthearted approach makes learning faster. Over the years I have watched thousands of students learn to draw and paint and I can state with complete

certainty that someone who is having fun while learning assimilates new information faster and has an easier time using it.

A fallacy about the arts promotes the idea that an artist must be serious. Who hasn't heard of "the serious artist"? Poppycock. Just the opposite should be true. Artists generally have more fun and enjoy life more fully than other people.

So while you're a student, it pays to treat learning new skills as an exciting adventure rather than as a serious undertaking. Enjoy your journey to excellence.

Your most valuable asset isn't a house. It isn't hidden under a mattress or in a bank. You find it when, in spite of everything, you exert your ability to maintain the unity and purity of your point of view. This kind of personal integrity leads to self-esteem.

Amid the execution of a work of art, opportunity abounds to thoroughly exercise personal integrity and keep it intact. Making the hundreds of correct decisions needed to accomplish an artistic creation and faithfully following through on each lead to the purest kind of self-fulfillment. The pride that an artist feels from a work well done comes from having been completely true to himself.

By keeping our promises to ourselves, we achieve perfection. When an artist breaks his promises to himself, he casts aside his self-esteem and sabotages his chance to succeed. No one can violate his own sense of right and wrong without paying the price. Only turning around and correcting errors and re-establishing integrity restores self-esteem.

No one has ever made all the correct decisions. Being one hundred percent perfect is impossible. Being as correct as one can be, however — which includes recognizing and making good our mistakes — is a fulfilling goal. In art you have the opportunity to be one of life's real winners by chasing perfection.

WATCH YOUR STEP

...BUT THE TEACHER WAS NICE

Any high-stakes game carries heavy penalties, and failure in the art game can be crushing. An artistic objective is no small desire. I have seen it mean more to some people than they are willing to admit, even to themselves. To many, it is the most important goal in life. But the waters of instruction in the arts can be dangerous to naive souls who dive in unprepared.

In drawing and painting classes, you will often see a discouraged beginner or even an advanced student quit after a disappointing try at a class. The new student never notices there wasn't any real help. The teacher never taught anything worthwhile, but duped students blame themselves and tell friends, "I can't do it. I just don't have enough talent. But the teacher was really nice."

Unfortunately, the vast majority of teachers in the arts believes that students don't stand a chance without tremendous natural talent. Students who don't respond to the class and who fail to succeed obviously have no talent. It's never the teacher's fault, it's the

student's. These teachers sleep blissfully at night tucked in by the talent myth.

Other instructors — those who have failed at their own artistic goals — have difficult crosses to bear. Not having found sound instruction themselves, a good number harbor deep personal frustrations. They teach because it's the closest thing to doing their own art. Unfortunately, college degrees don't guarantee artistic success. It's difficult to feel you can help another when you haven't been helped yourself.

Some instructors fill large gaps in their own understanding with dreamed-up, outrageous theories about how one must work. They inflate their personal opinions into axioms. New students are particularly susceptible to narrow, unworkable ideas, especially those that sound hip or avant-garde, and can get sidetracked for years or even derailed for a lifetime.

Perhaps this has happened to you or someone you know. It's no fun to feel you failed, and horrendous when you blame yourself for what is really the lack of workable instruction.

BOHEMIA WINS IT ALL

It's common knowledge in the fields of drawing and painting that you must first submit a portfolio if you want to attend a major private art institute or a large public university arts department. When I submitted mine, applicants had to already know how to draw. Luckily, I had studied privately for several years.

This is a curious situation. Suppose you wanted to attend medical school. Would you first have to know how to diagnose disease, prescribe medication and perform surgery before they admitted you?

Nowadays, as tides ebb and flow, art school committees are much more interested in how "creative" you are — in their estimation, of course. Talent or skill is not much of a criterion anymore.

It could be assumed that due to this admittance practice of seeking out the specially chosen creative few, the vast majority of youngsters at these schools would go on to brilliant careers in the fine arts. Exactly the reverse is true — their successes are infinitesimally rare, a disgraceful result for a so-called education in art. You would know just how disgraceful if you spent the past twenty-five years as I have, picking up the broken pieces. Their number is staggering.

We are talking about a lot of very expensive diplomas for which nearly all the students have gone heavily into debt yet still lack the skills to succeed. One very good reason for the dismal statistics is the abandonment of the traditional basics of drawing and painting. Though the talent myth has always prevailed, it was far easier to acquire traditional skills or to refine one's talents in art schools back in 1920 than it was in 1970 or still is today. Every so often, someone in their late seventies or older who attended art school way back when comes to me for instruction. Their basic skills are already firmly in place. Back

then, when the modern art movement was only beginning to gain momentum, these schools still taught the ABCs of art.

But as the arts went through convulsive changes, the time-proven, traditional skills of drawing and painting used by Leonardo, Rembrandt, and Degas were declared invalid. Those in high places in our art schools, colleges and universities tossed them out for a few new artistic experiments and thereby denied young students the opportunity to learn the magic of past masters. These "educators" failed in their obligation to provide students with a sound foundation in fine art that, at the very least, should have given them the vital skills needed for continued artistic growth and development. What would happen to the field of physics if the same were done with Copernicus or Newton?

Art schools ignored or concealed the fact that Picasso and Matisse had their creativity grounded solidly in these older talents and traditions. Many times during their long careers, both these great artists drew new strength from the basics. Both of them could and did return to representational art to stabilize, for they knew that everyone needs the natural universe as a meeting ground before embarking upon new paths. Both lived to be old and productive painters. They avoided painting themselves into a corner as did those who followed.

Pablo Picasso exemplified the practice of discarding the old for the new — but only after acquiring a

formidable arsenal of talent from his art-teacher father. Though thoroughly trained in the basics, Picasso shelved his traditional skills and led the modern art movement away from realistic painting. All of his devotees in Bohemia immediately followed, but most of them didn't have the foundation in drawing and painting that he did.

It was also a time when photography became fashionable. Young artists were no longer given to understand that Rembrandt and the other masters had not copied the world as a photograph does but had created new ways to see.

The talents and traditions of oil painting that began in the days of the great painter Titian, traditions that firmly supported the art of painting for centuries, all but vanished from sight. The knowledge and magical talents that enabled us to depict our three-dimensional world were dismissed like unwanted servants after five hundred years of faithful service. Suddenly they were too bourgeois.

In recent years, controversy in education has focused on the failure to impart basic skills to our young. Sensible evaluation brings the hope of a sharp turnaround from failed progressive-education experiments to more traditional methods that ensure our children learn adequate reading, writing and mathematics skills.

However, it is little known that this disintegration of basic knowledge first happened in the art schools. Art does lead the way, for better or for worse.

THE GURUS

The arts have always been a favorite haven of quacks and self-styled gurus, both among teachers and artists. Armed with an array of artsy accoutrements, they are enormously convincing to young and eager new members of the avant-garde. There is always an enthusiastic new audience of unsuspecting young students willing to exchange their own dreams for where it's at in the contemporary art scene.

The messiahs deliberately exploit and sidetrack fledgling artists to forget about the further acquisition of skills. Quite often the gullible are coaxed to drop the use of whatever talent they already possess, "for creativity's sake." Confusions mount as they are fooled into believing that all ideas outside of the fleeting but trendy scene are invalid, tasteless and uncreative. Sacrificed on the altar of hip, their work becomes shockingly different than before — flashy but soulless. This might give insight into the sudden changes engulfing someone you know in the arts.

It can take years for these people to finally admit they were misled. Some never do. You see them fight their way through life, trying to hold onto the old ranting.

❖ THE MISSING PIECE ❖

If a life can be looked upon as a puzzle we try to fit together as we live and learn, the piece most often missing is artistic self-expression. We seem to lay our hands more easily on pieces such as being a father, mother, son, daughter, lover, provider, worker, spectator, civic supporter, etc. Because of the talent myth and the day-to-day demands of mere existence, the exercise of self-expression has been lacking in the lives of all but a very few.

Until you actually acquire some talent and see for yourself what you are truly capable of, it's hard to fully comprehend the importance of creative pursuits. Still, most people do have an intuitive inkling of what lies in store. They know it's no accident that artistic creation has provided others with their greatest riches.

I remember wondering as a boy how I would ever earn enough money to buy a home and support a family. It was all so overwhelming. Then little by little, almost without noticing, it all seemed to happen. You just start, keep going, and one day you complete your first recognizable portrait in oils. Nearly everything I ever achieved looked almost impossible at one time.

As hundreds of thousands before you have done, you can find your greatest personal happiness by becoming a fine artist.

Like the Sirens of the sea, the urge to create forever beckons. You probably have scores of years left to develop artistically. If you are going to do it, do it right.

Shoot for the stars!

CHAPTER NINE

THE TEACHER

GOING IT ALONE

Anyone can learn and improve their artistic abilities—but only when their teacher knows what to teach and has the certainty that any student can learn. In the fields of drawing and painting, this is rare—especially in today's colleges, universities and art schools. Add to this overcrowded adult-education courses and private classes with bad, misleading, nullifying or nonexistent instruction and we've had thousands of once eager students saying to themselves, "This isn't for me!"

Those with determination struggle on by themselves rather than be subjected to more folly in these classes. Thousands try to succeed alone. A few miraculously do.

Many of the disappointed switch to forms of expression requiring far less skill; an expensive camera has consoled many a frustrated painter. Multitudes of others choose from dozens of how-to books, or copy pictures from the backs of matchbooks and send away for critiques. Thousands more

rise at six a.m. to watch instructional television programs or try to imitate other artists. The creative urge prods them to keep trying.

For many, the arts have become a form of hobby-therapy. They spend millions of idle hours dabbling, trying to enjoy the moment despite the inner conviction they can't really be artists.

It isn't true. What would they believe themselves capable of if really good instruction were available and a talent myth didn't hold sway? Going it alone is not the answer. To succeed in the arts, you need another to coax, teach and encourage you.

Today, videocassettes, DVDs and CD-ROMs are beginning to substitute for personal instruction. The Internet, which permits rapid interchange of communication between live human beings, presents interesting possibilities for long-distance art instruction. However, there is really no substitute for one having someone, who really knows the basics, coach him through any rough spots.

SEEK AND YE SHALL FIND

If you want to sing, dance, play or compose music, paint, sculpt, write or act, the answer is to look until you find the teacher who can help.

Though not in huge numbers, we exist. Once you decide which art form to pursue, your next step is to embark on a search for a good teacher. If you're interested only in dabbling you'll find a dabbler for a

teacher, but a desire for excellence will lead you to an excellent teacher. You may bounce off some bad instruction at first, but if you keep looking you'll eventually find what you need.

Private teachers with a good reputation, and who can teach the genuine basics, are your best bet. Some of them are accomplished in their art and teach because they feel a real desire to share their knowledge and skill.

Don't make the cost of learning an overriding factor. You're not buying a meal that will be gone after you eat it or a car that will need replacement in a few years. You are buying knowledge that can enrich the rest of your life. Acquiring the basic skills from a fine teacher in the arts is like finding pure gold.

Although you may find a good instructor or two in larger college art departments and private art schools, don't count on it. You don't have to take my word for it—invest the time to visit some of these schools. Talk to students and check out their work; check out the instructor's work too. Find out about the methods of instruction. In short, do your homework before you enroll. Remember, expensive diplomas can't paint, dance, or sing. Trust your intuition rather than what is promised or said.

Every art form has different teaching methods. In music, it's common to study privately, with daily practice required at home. In drawing and painting, routine practice is not as essential. With correct instruction, you can learn to draw and paint without much practice.

Small drawing or painting classes with individual instruction are the best. Also try to find classes where you can learn at your own rate of speed so you won't be under pressure if you're slow or held back if you're fast.

The best instruction first provides you with some pertinent information about a skill, then an exercise or two to help you acquire it. A format made up of these two steps for each new skill, given in their order of importance, is most effective.

Though helpful at times, demonstrations by teachers can also be a drawback, especially for a new student. Students who tend to get stuck in "how the teacher does it" or in little things that are part of the teacher's own style run the risk of ending up a poor imitation of the teacher. Students in awe of particular teachers emulate them instead of taking the time to develop their own style and reflect their own viewpoints. In some private painting schools and classes, the teacher does all the work and students merely follow along. You'd do better with a paint-by-numbers set.

Most of the battle is won when an instructor teaches the correct basics. These get you going and keep you going. You can tell you're learning the correct basics when you find yourself doing better and better on your own without continuous help from the instructor.

If you are lucky enough to find one, a master will make the best instructor by far. Every master knows the real value of the basics for they are the primary

reason for his excellence. A master is someone who not only can do it but has also broken down all the steps involved. The true master knows and understands it all — from top to bottom. He also has nothing to lose if you succeed and will do everything he can to see that you do.

The only real test of an instructor is whether or not students are improving. Do they look happy? Are they learning? Before you start with a new instructor, ask him point blank if he can help you. If you feel you have little talent to begin with, say so. If he doesn't have the knowledge to help you, give him a chance to tell you. Then keep looking.

Although of course you have to do your part, the responsibility for teaching you the basics of any subject sits with the instructor. Ninety-five percent of success lies in his imparting the true basic skills in their correct sequence so they can build properly one on the other. Later, as you become more adept, the responsibility will lie ninety-five percent with you.

It's the same for all study. First a child is taught his ABC's, then to read properly. Later, with his reading basics well established, it is up to him to find books and continue his development in literature.

Finally, although the instructor is largely responsible for how you learn in the beginning, he can't succeed without diligence on your part. Always make sure your teacher knows when you have not understood something. You and your teacher form a team. With his or her help, you can attain excellence.

WHAT TO LOOK FOR

Here are a few pointers on what to look for in a teacher.

1. Do you like the teacher's work?

It's important to respect what your teacher does. After all, no matter how objective he is about his work, he'll teach you what he knows — and what he knows will be reflected in what he does.

On the other hand, don't judge a teacher only by his work. Teaching is not the same as doing, and some teachers are very good painters but terrible instructors. Others don't have enough intention to help students through the rough spots. Although a teacher must have enough knowledge and talent to merit teaching his subject, the determination to help you and see that you do indeed learn should be his top priority.

2. Does your teacher start with the fundamentals?

A gradual approach is necessary to learning. You start with the most basic fundamentals and continue from there. Too many instructors assume that you already know them, or worse, don't know them well enough themselves to teach them. Also, some people involved in an art form for a long time use the fundamentals so automatically they're no longer aware of them. This, of course, would be a terrible failure on the part of a teacher — but it does happen.

3. Are you actually improving?

If the instructor teaches you the basic skills step by

step, one after the other, making sure you master each one before moving on to the next, you should improve. If not, something is wrong with the instruction, not with you. A good instructor should be able to break the needed skills down into steps simple enough for you to learn successfully.

4. Are you being treated as an individual?

We all have different strengths and weaknesses. A good teacher realizes this and treats each student as an individual. A poor teacher treats everyone the same or has a few favorite students. You're better off finding another one.

5. Is it a safe place in which to learn?

Any learning environment must feel totally safe. This is especially true when learning an art form where the stakes are so high and the intimidation factor can be so great. If you feel intimidated in any way when you go to class, it's probably the teacher's fault, even if the intimidation comes from other students. A good teacher controls the students and is responsible for how they make one another feel. Some instructors themselves intimidate students with an overbearing manner. Some set themselves up as authorities or unattainable examples of talent. Some favor a few students over others. If any of this is happening, find a new teacher.

6. Are there too many people in your class?

If there are more than ten students with only one instructor, you won't benefit from what he has to give you. Because we are all so different in awareness and

ability, there must be a way for you to receive some one-on-one instruction.

7. Are you getting individual help?

Perhaps there's a piece of knowledge you don't quite get or a technique you just can't seem to apply. Is the teacher accessible and does he or she take the time to help you? Is he or she prompt with the help but patient with your problem? Can the teacher get to the root of your difficulty and help sort it out? If not, you're wasting your time and money.

8. Is there criticism without help?

An overly critical teacher can make you give up. Criticism without instruction on how to improve is a hindrance, not a help. Rather than continually point-ing out what is wrong with what you're doing, a good teacher should give you tasks you *can* do. A student progresses by winning, not by losing. Ask yourself if you feel better since you started the class — better about yourself, your ability, and what you are doing. If not, change teachers.

9. Are you training with people you like?

It helps to learn with people who encourage and support one another, admire each other's efforts, and are genuinely pleased to see others progress. It also helps to have friends with whom you can discuss the art form. Artistic companionship causes growth.

10. Are you pitted against others?

Some teachers feel that competition among stu-dents is necessary to spur them on. It isn't. Perhaps the teacher will be less bored but it does nothing for

students, particularly in the arts. You should only be competing against your present limitations.

If you aren't getting better and having fun while doing so, your instruction is falling down on one or more of these points. Go over the list and find out exactly what's wrong. If it isn't something you can correct by talking to your teacher, change to another.

All art forms appear difficult to any beginner. A good teacher will show you not only that excellence is attainable, but also how. Even though you may not feel you can do it, a good teacher *knows you can* and will see to it that you learn to.

It's very satisfying to achieve long-range goals you have set for yourself in life. Perhaps you have achieved what you set out to do. You've won your game. But victory can bring with it great loss — the game isn't only won, it's over.

You now have four choices.

The first choice is to simply stop playing and not find a new game. We've all seen the negative effects of premature retirement.

The second choice is to continue playing without setting new goals. Most of us know someone who was very successful years ago and now lives in the past while grinding through his current life — or worse, as an expert problem-solver faced with a lack of creative problems, now manufacturing self-destructive problems.

The third choice is to create a larger game out of the one already won. To some degree, expanding the existing game fills the void. Too often, though, additional goals, no matter their scope, are anticlimactic.

The fourth choice, the sanest and most positive for an individual who has already won his chosen game, is to expand into the arts and create a new game with new personal goals — be it as a painter, writer, singer, actor, or in some other field of the arts.

The smart person will prepare ahead of time to

play the next game, and while in the latter phases of winning the current game, start training in the arts.

Most people have undeveloped aesthetic abilities. They've remained untapped in part due to the fear of failure. As well, some men still feel the arts are unmanly—a sad legacy of past concepts of masculinity. Others still fixated on materialistic goals don't readily see the value in artistic pursuits.

Although most people don't easily express their inner desires to create in the arts, many more would do so if they thought it was a game they could win. I hope this book dispels the myth that may have been stopping you from striving for and attaining artistic goals.

CHAPTER TEN

The Learning Process

Your Role

You also have responsibilities as a student.

The first is to realize that you don't know, and then to recognize *what* you don't know. The most frustrating student for the teacher is the one who thinks he already knows it all, for he will never learn. He arrives for instruction, his mind filled with pre-conceived ideas and opinions. Certainly you may have opinions, but don't let them get in the way of learning. If you are lucky enough to find a teacher you respect, let them teach you.

Your next responsibility is to start at the beginning. Learning and development take time. Don't, through impatience, bypass the basics, the foundation upon which you will build the rest of your creative life. It's easy to demand immediate masterpieces of yourself but disastrous to do so. Achieving excellence takes persistence and time.

Thirdly, go easy on yourself. Don't expect more than you can deliver. It's fine to have goals, but make them attainable. Be realistic. And always pat yourself

on the back for what you have accomplished. Be your own best friend. Encourage yourself.

WHAT'S IMPORTANT?

When we talk about acquiring artistic talent we are talking about acquiring knowledge; therefore we had better address past learning habits. During our school experiences we all picked up some false ideas.

The first false idea is that incomplete knowledge is acceptable. Its probable source is the grading system. Though you need to know a subject 100%, 65% has been a passing grade and 90% has been considered excellent. The result of such low standards is mediocrity in basics like reading, writing, and arithmetic.

While grading might not matter much in subjects which will seldom be applied, such as history, passing a student with only a 75% in arithmetic and pushing him on to geometry results in his going through life unable to master figures. The same is true in training to be an artist. In a basic art course, you don't want to go on unless you *understand it all.* If you do go on, what you missed will plague you and eventually stop you.

The good news is that given the proper instruction, anyone is capable of complete knowledge in any subject. This may sound revolutionary, but it's actually an old idea and quite attainable.

Current testing systems create yet another important falsity. What is the principal export of Mozambique? What is the primary cause of world hunger? Both

answers are worth two points on the final examination, yet the questions are of strikingly different importance. Grading and teaching methods usually gloss over the idea that some pieces of knowledge are more important than others. By the time we leave school, our ability to evaluate the relative importance of information is often undeveloped or even damaged. A car's engine is more important than its color, yet many people select their cars by color.

The ability to determine the importance of any piece of knowledge relative to others is crucial for success in the arts.

A Guide to Fulfillment

Here are some tips to make it easier for you to learn:

1. Be a student. Be prepared to learn.
2. Have the acquisition of talents as your goal — they are a prerequisite to art.
3. Don't rush through the basics. Learn the reasons why the most fundamental skills of your art form are so important. Once they are mastered, your progress will be steady and rapid.
4. Know when you've achieved some new ability or kicked a bad habit, and give yourself a pat on the back. There's no single panacea, gimmick, or secret to bring you success as an artist. Overall success consists of dozens and dozens of smaller successes. Recognize each as an accomplishment.

5. Take responsibility for your pursuit. Don't try to slide by—as so many of us learned to do in school—but make sure you know and can apply your lessons 100%. Don't deceive yourself into believing you can when you can't. One must first be able to be wrong in order to be right.

6. Always handle any disagreement you have with your teacher or any confusion or conflict with the information he gives you. If you have studied the art form before, your new teacher may seem to contradict the old on some points. Bring these up and sort them out.

7. If you have real difficulties with your study, let your teacher know right away. Also speak up if you currently have a distraction in your life. It will help the teacher to help you.

8. Practice whenever you can, but never put yourself down because other duties make it impossible at times. Keeping the rest of your life going is important to your ultimate success as an artist. Still, try to establish a practice schedule and stick to it.

9. Don't wait until you are a master to produce. Producing leads one to higher quality. The more artistic projects you do, the better your work will be.

10. Produce work on your own that you can easily do. By all means challenge yourself, but don't go into waters over your head.

11. Remember that you are learning. Let others know you are a student. Don't pretend you can already do something well. Stay in the practice field until you are ready to play.
12. Never compare your abilities or your rate of learning to another's. Art is not a race. Learn at your own pace. Art is a lifelong pursuit, and like fine wine it gets better with age.
13. Stay with an instructor as long as you're improving. Don't pay attention to other people's opinions about your progress. You are the one who will know.
14. Never study in more than one class or with different methods or teachers at the same time. Only confusion will result.
15. Befriend other students and those who are interested in your art form. Mutual interest with others can stimulate the learning process and bring about as much knowledge as instruction.
16. Help those who are helping you as an artist in every way you can. You are receiving a precious gift and anyone who helps you obtain it deserves your support.

PERIODS OF PERSONAL GROWTH

When I look back on my years as a painter, I see four main periods of personal artistic growth. As a boy I was fortunate to study with a fine old painter.

He helped me to dream my dream and to start realizing it. From him I learned enough of the basics to stumble along until the crushing experience of a major fine-arts school suppressed my dream for a while. My biggest regret is that I didn't spend more time in his classes and studio. I didn't fully appreciate it at the time, but Giuseppi Trotta was a living master. His ability to handle paint was saint-like.

My next period of personal growth came when a great American master, years after his death, taught me how to paint in watercolor. I succeeded as a professional painter because of Winslow Homer. At the time, I needed to paint to survive. I lived on a beautiful tropical island and, because of what I learned from Homer's paintings, my story became one of rags to riches. I spent nearly two years trying to *be* this magician of light and color in order to learn his tricks. I studied his paintings in books and in museums. I kept taking them apart and reassembling them while I was painting — or while eating, or sleeping — any time, anywhere. And I became a very successful watercolorist.

To further make the point of the importance of studying the works of the masters in a field, a group of students were once in a museum duplicating a painting by John Singer Sargent when, to their amazement, in walked the great painter himself. He sat down across the hall, opened his paint box, and started duplicating a Vermeer. And Fantin LaTour, one of the finest floral painters ever, spent eighteen

years in the Louvre duplicating the masters. There is no end to knowledge in art, nor any substitute for studying the masters.

My next period of personal growth had much to do with a personal quest to become a better person. Though I had achieved great material success and recognition as a painter on St. Thomas, something was missing for me. I recognized a deep need to improve the image that I had of myself.

It was then that I came upon the writings and teachings of L. Ron Hubbard, and began my journey of self-improvement. Not only did I achieve my goal to improve my self-image; I also became more enlightened regarding the entire subject of art, and how to properly instruct another in a given subject. Due to this association, I gained my own certainty that *anyone* could learn if given the correct information in the correct sequence. It was my exposure to the remarkable knowledge of Mr. Hubbard that paved the way for me to begin my career teaching others.

The fourth period of personal growth began about twenty five years ago when I started teaching others to draw and paint. I decided that a student who had no talent at all could and would learn to draw well. And he did. I found I could teach him in spite of the talent myth. Helping him forced me to understand for the first time how I myself drew.

Teaching others is perhaps the greatest teacher. The process has forced me to investigate, clarify, and gain a complete understanding of the process of

building a work of art and the true nature of being an artist. It has been a wonderful experience of growth. I paint better for having taught and, more importantly, I love every minute of it.

While you may not want to teach or write a book, after learning some basics, there is no better way for you to further your artistic growth than to study the masters. This is true in any of the arts. Only a small handful of artists alive today could possibly help you learn skills equal to the masters. What better teachers of portrait painting than Rembrandt or Velazquez, of music than Bach or Mozart, of writing than Shakespeare or Whitman? You'll see that they all had those same fundamentals in common, and that they added their own expression to them. You should seek from them the uniqueness of their individual treatments, techniques and viewpoints. By studying them, you widen your artistic vocabulary and learn to express yourself in many different and exciting ways — which in turn enables you to explore the myriad avenues along which your creativity can travel. Studying the masters is a journey of expansion. These, and great spirits like them, were the pioneers of perception, the giants of communication, the purveyors of humanity's most treasured beauties.

A student can learn a great deal by comparing the oil painting techniques of the early masters with those of artists from other periods — for instance, the Impressionists. Each group was after different effects. One learns the basic tricks of different painting meth-

ods — the tonal effects of a Rembrandt, the amazing use of line of Cézanne — adds them to his own repertoire, passes them through his own unique take on art and life, and creates his own tricks. Individual expressiveness begins to emerge. Now, practice and production can bring the artist to his peak.

But even through your awe of them, see that great painters were human too. They produced great works — and some not-so-great works. Don't worship, but observe, evaluate, and learn. Once you're familiar with their growth, it becomes clear that some of them started with little.

There's an important trick to discovering the magic of a past great painter. Never simply copy his paintings. Instead, try to become him. Study more of his works and get a feeling for him as an artist. Then duplicate *how* he did the painting — the steps the great painter took to accomplish it.

An important part of this trick is to get the idea that you are looking at whatever subject matter he was looking at, as it was then. Note the differences between the real thing and the painting. Now you'll see the real magic, the individual expressiveness of the painter.

◈ Ending the Game ◈

When I was twenty, I was drafted into the armed services and sent overseas to Korea. For a long time after my discharge I had a bitter taste in my mouth. I felt two years had been taken from me and I resented it. I wasn't a very patriotic citizen after that.

One day thirty years later a Korean man in his mid-forties came into one of my art schools searching for an art book to give his son who was studying painting in Seoul. After he bought the book and as he was leaving, I happened to mention that I'd served in Korea.

He turned back, reached out and gave me the warmest handshake I have ever had. With a wonderful smile he said, "Thank you. Thank you so much. You have no idea how much we appreciate what you and those like you did for us."

Suddenly a great cloud lifted. Once again I felt a rekindling of pride in being an American. So I had done something after all with those two youthful years.

It's very important to end activities you are no longer involved or interested in, before beginning a new endeavor. Even those times that you never really wanted to be a part of can end happily by acknowledging them. Then you are free to begin anew, fresh and unentangled by the past.

ARTISTIC FULFILLMENT

THE REAL YOU

Every human being has vast potential for creating beauty. This potential manifests through our actions, our works, our view of ourselves or our works, our view of others and their works, and through an aesthetic response to the universe around us. Anyone can further develop his or her aesthetic sensibilities to better communicate in any of the arts.

Artistic expression that reflects the real you is the most meaningful of all. It is composed of all the talents, understandings, and the little things that make your way of expressing yourself different from those of others. Together these reveal the unique qualities of your distinct personality. They are each little symbols of you.

We are all blessed with unique qualities. Every man, woman and child has a distinctive personality. Of all the billions, no two people are the same. Only when one is aware of himself as himself and not as a social facade can he truly feel joy and achieve personal fulfillment. A fine artist will succeed to the degree that he remains himself.

It can be difficult to see yourself as you are or as others do. If a person begins to accept himself and even starts liking what he does simply because he did it, he begins to notice his own uniqueness.

When viewing a Rembrandt, regardless of subject or style, you'll see that Rembrandt the individual permeates all of his work. When reading Shakespeare, whether a sonnet, a comedy or a tragedy, we re-experience Shakespeare himself. We marvel at Baryshnikov, regardless of the ballet, for his unique qualities. When Bernstein conducted we sat spellbound. Millions gained pleasure watching Bogart and Hepburn be themselves as characters in their films. They didn't change themselves to play a role, they fit themselves into it.

A true artist doesn't try to be different; he knows he is different. He develops skills to express his differences. One becomes a fine artist and acquires talents in order to express himself, not to suppress himself.

When all of the above pieces are ready to be blended at will into unique rhythms of self-expression, a fine artist can begin to reach his creative pinnacle.

The truth is, you create unlike anyone else on the face of the earth.

DEVELOPING ARTISTICALLY

How then do you go about developing yourself artistically? Some people are inclined towards more than one of the arts as expressive outlets. You may

enjoy singing and sculpting, or writing and acting. It is better, however, to concentrate upon succeeding in one and save the others for later than to try to do all at once. A multi-talented or multi-interested person often fails due to lack of focus on any one activity. Don't become a jack of all trades and master of none. Instead, choose the one in which you feel you have the best chance of success.

Developing self-expression can be likened to the growth and evolution of your own personal alphabet in the art form you choose. Each unique personal touch represents a letter in your alphabet. When fully formed, this alphabet becomes your own style. Van Gogh's brushwork, his use of bright colors in certain combinations, a particular urgency about his work—these, along with many other nuances, make up a Van Gogh.

Lots of elements contribute to building your ability to express yourself. The major one is the acquisition of talent. Knowing and understanding the many skills of a particular art form can stimulate new ways of expression. Certain methods and tools become favorites because they best suit your own tastes.

Taking note of your own moments of intense aesthetic pleasure and analyzing what brought them about is vital to building self-expression. Driving through mountain country one day, you see an unusually beautiful array of different greens on a hillside. The way these colors behave with one another intrigues you. Later, you render this effect in oils and

introduce these color relationships into your painting vocabulary. Their use becomes a reflection of you as a painter.

An artist is best at what he knows. Many writers succeed by writing fiction based upon what they have observed and experienced. What better subject matter for self-expression?

There are also hidden attributes of self-expression. Sometimes they are too close to you for you to notice, but others can see them. Your heritage and early influences are much a part of such attributes. Trying to figure them out is often futile, but they may reveal themselves to you as you work and observe.

You can learn from others, but as you attain your own artistry you can't allow others to think for you. Eventually you must learn to make your own decisions and be your own person. Holding onto your own beliefs is important.

People who feel degraded are never fully themselves, nor can they originate or create well. So put the stamp of approval on yourself and on your own ideas, or the ones you once had when you felt best about yourself. Your individuality consists of your unfettered unique personality, your tastes, your ideas — those qualities which make you so different from everyone else.

If you maintain your own point of view in life, if you remain your own person and don't live through the opinions of others, then you have character and individuality. If you work to strengthen your talents,

your personal integrity and your finer qualities, then you have the makings of a great human being, a great communicator, and a great artist.

No one is born great. But each of us has the potential for greatness. Greatness is gained through increasing one's own certainty of communicating and strengthening one's character. In short, you must work at it. Excellence adorns those who earn it.

REMAINING YOURSELF

During the period when the French Impressionists were a tightly knit group, it was often difficult to tell some of their work apart. Only later, when each went off on his or her own to regain and fully develop an individual artistic viewpoint, did each reach success as a painter.

Being part of a group has its liabilities as well as assets. Individuality stems from individuals, not from groups. Movements promote causes, not beauty. Painters in groups tend to paint alike because they lessen their individuality for the sake of the group.

In a group making up the contemporary art scene, an artist can try to be an original and end up being a copy. He can become too involved in a group whose membership dues are agreements. Agreements hold groups together but also foster similarity rather than originality. A group of people who all have the goal to be different contains the seeds of their mutual conformity.

Why do the great artists endure? Because they are true individuals, not because they belong to a group. Strong, talented individuals who create out of love for their art can't help but produce works that are worthwhile and admirable.

There are thousands of highly talented people in the arts, but many are weak as individuals, uncertain of their own opinions and too in need of acceptance and status.

Some of these people have tremendous technical ability but their work has no personal flavor and spark.

The ideal situation is to possess both talent and originality. A person can obtain talent, but he must become his own person to be truly original. Being your own person involves observing for yourself, making your own judgments, and not obsessively agreeing with others.

Think back to when you were a child. Before you agreed or were forced to agree with so much around you, you were more creative. Go back and start from there.

This doesn't mean breaking all of your existing agreements or not joining groups. The point is simply that agreements made not from your own point of view, nor out of your own sense of correctness, aren't really agreements but rules.

When people think too little of themselves, they tend to think too much of others. When they cast out their own ideals and adopt whatever someone else is

promoting, they seldom realize that they have lost any chance at real success, happiness, and fulfillment. No one has ever been fulfilled by assuming another's viewpoint. The only thing that really makes you different is being yourself.

This doesn't mean, however, that an artist can attain true self-expression through some outlandish idea designed just to attract attention by being different — that's creative deception. If true to yourself, your purposes will be purer, simpler and higher than mere hucksterism. Shallowness is not relevant to art. When with a great artist or among his works, you know you are in the presence of a great personality, not a great cause.

No one should worry about how to become creative. He should be more concerned about how to regain the creativeness he once had by reaffirming his own true individuality and originality.

PERFECTION

Artists strive for perfection through their talents and in each of their works.

Every new play a writer creates has its own set of facts. An artist's every work is an exciting and different set of circumstances. A new potential for creating perfection lies within the execution of each one. When he achieves something close to his ideal — that which he clearly envisioned — he has approached artistic perfection. When someone dreams up an idea

then creates something which causes another to experience that idea, he has achieved the most that an artist can hope for.

A painter, for example, wants his painting to affect you in an aesthetic way — he wants you to experience the beauty he sees. He also desires you to experience a sense of freedom and a wider point of view. These are his objectives for the painting.

He selects a bird in flight as the subject matter. It is soaring in an immense sky, surveying countless miles. These are symbols, chosen and rendered in his own unique way to convey his message. He makes the painting to suit his purpose, the envisioned effect. It is his vehicle. He works to perfect the painting.

When it is finished, you see it. A sense of beauty overcomes you, combined with the thought of freedom and an expanded view of life. The execution of the work was perfect — it caused the desired effect. It attained perfection for both the artist and his audience. This is what fine art is all about.

FULFILLMENT

The ultimate objective for pursuing one's excellence is the admiration of self. Fulfillment through work is possible, but work alone doesn't guarantee it. Millions of people work all their lives yet are never fulfilled.

Fulfillment necessitates an accomplishment, a completion of something. Self-fulfillment would be carrying out a promise made to yourself, filling an

order you have placed with yourself for personal achievement.

You gain fulfillment through an activity if you know your game and stick to it. It's vital to your success and personal joy to know exactly what you want to accomplish before setting out on any adventure. Just as you don't get on a plane without having a destination, a poet's words aren't an end to themselves. His goal is to use them to express an idea and create a certain emotion in the reader or listener.

In the fine arts, you can play lots of games within a relatively short span of time. To the painter, every painting is a new game with new goals.

There is no artistic fulfillment in completing a work just because you are tired of working on it, or of ending up with something other than what you set out to do. You attain real fulfillment only through accomplishing your original objective — creating the effects that you said you would.

Keeping your promise.

THE SKY'S THE LIMIT

Daily, hundreds of people take up golf. Getting good at it requires the desire to do well, expert instruction, self-discipline and practice. Although some new golfers spend months at the driving range before allowing themselves to play nine holes, tens of thousands go out on the golf links each day. Most play a fair game at best, but this doesn't prevent them

from enjoying it. No one tells golfers they need nat-
ural talent to play, nor do most compare themselves
to Jack Nicklaus or Tiger Woods. Instead of plunging
into self-criticism about not playing as well as the
masters, they simply learn to play as well as they can.
And some of those with a strong desire to excel even
go on to become masters.

These same principles and attitudes apply to art.

When we admire another's skill at doing some-
thing, it can appear more difficult than it really is. If
in spite of your awe of Rembrandt you find a good
instructor and assume the role of a painter rather
than an awe-struck admirer, learning to paint can be
much, much easier than you think.

Any complex activity can be broken down into
understandable and simple steps. By learning the cor-
rect steps in the proper sequence, you can acquire any
talent. The prerequisites for success at anything are
always the same: an unwavering desire to do it, the
right training, self-discipline, and the persistence to see
it through. With these, you will eventually win at any
activity. Although natural talent helps, it isn't essential.

Comedian Fred Allen once said, "If an actor acts
long enough, they'll build a theater around him." You
just have to stick to it.

The way to acquire talent is to receive instruction
from someone who understands the subject from the
bottom up — someone who can impart information
to you starting with the most basic building blocks of
that art.

One of the first things my students learn is the meaning of the word *draw*. Not what they think it means or what I think it means, but right out of any dictionary. The main definition is "to pull" or "to drag". Once they know this, nearly all students, with or without talent — and most for the first time ever — realize how to hold a stick of charcoal and start to sketch freely. If you begin at the very beginning instead of the middle, the speed of learning dramatically accelerates.

In spite of teachers who only work with the naturally talented, there are some caring, knowledgeable teachers in all the arts who believe that anyone with enough persistence, even those without natural gifts, can learn.

Are you a museum browser, a music lover, or an avid reader? Then isn't it time that you became a creator, not just a spectator? How much talent can you acquire? How good can you be?

The sky is the limit.

❂ Renaissance II ❂

Until recently, humankind's attention has been firmly fixed on survival. Though millions are still hungry and impoverished, today we have the technological know-how to deal with our material concerns. Automation and computerization are going to give us all a chance to play games in the arts. The great Renaissance begun centuries ago has evolved into the next — a personal renaissance for each human being. We each have our own creativity to explore and the rewards to reap.

Perhaps in the past we needed a talent myth to keep our attention on survival, but any such necessity is rapidly diminishing. Will we create and play destructive games, or games that add joy to our lives and those of the people around us?

Thousands have made their choice and are studying and training daily in the arts. You don't have to stop what you're doing; you can learn part-time to be a painter or singer or writer. A few hours a week is all it takes to begin. You can acquire the talent. You need only the interest, desire and determination. You can enrich your life and the life of the culture in which we live. You deserve it.

Epilogue

We all have the potential for boundless creations. Not surprisingly, people with a creative approach have more fulfilling lives.

But most of us meander through life without taking stock of ourselves and the world around us. We move from one thing to the next in a continuous effort to muddle through, accumulating and losing friends, acquaintances, possessions and interests along the way. Events seem to string out through time with no real beginnings or endings. Goals are forgotten as new ones pile upon the old.

When trained in the arts, you start to think in a different way. You learn to begin a work and to finish it. Using the disciplines of fine art, you create exact goals and see them through to the end. When this way of thinking spills over into day-to-day living, life changes for the better.

Many of us give little thought to the order, unity and harmony of the different elements in our lives. We tend to handle each without proper regard to its relative importance. We too often leap in to handle the problem right in front of our noses rather than

work from large to small and find the more fundamental ones that are causing the constant stream of emergencies.

The man who dedicates his life to building up his business only to lose his wife, the woman who concentrates all her efforts on being a wife and mother only later to regret the interests she put aside — what if they were aware of working from large to small, of cycling throughout their whole lives, of always relating its parts? What if they knew the steps of creating so they could put direction and order into all facets of their lives? And what if they possessed the self-esteem that goes with such successes?

Biased as I am, I think everyone should be involved in the arts. It's your life — nobody else's. You have to live it. You can't live it for or through others.

You can make the very best of it. Fulfillment comes from self, not from others. Genuine admiration must come from yourself before it can come from others. The pursuit of personal excellence in the arts is a direct route to such fulfillment.

The enormous changes we saw in the past century will multiply in scope and rapidity in this one. But such progress can carry with it a dehumanizing effect on us all. Our hope for sanity and fulfillment lies in the one place no machine or electronic device can enter—our own individual universe of thought, the birthplace of creativity and the arts. It is here that each of us can make a stand.

ABOUT THE AUTHOR

Perhaps no one has enabled so many others to acquire artistic talent as has Larry Gluck. His breakthroughs in fine art training have led to success and artistic fulfillment for literally tens of thousands of people of all ages from all walks of life, regardless of the amount of natural talent each individual began with.

Born April 9, 1931 in New York, Larry studied under the tutelage of a fine portrait artist, Giuseppi Trotta, a schoolmate of Picasso. He next attended one of the "most prestigious" art schools, believing he would receive the necessary instruction to enter the world of professional representational painting and perhaps go on to greatness. But art training institutes had abandoned the world of representational art for modern art. Therefore, like most alumni, Larry left school completely disillusioned about making it as a representational artist. Nothing of value had been taught to him; he saw no improvement in his work.

Years later, this negative experience would be the catalyst that would result in a revolution in art education.

In the 1950s, Larry served a tour of duty in Korea, after which he pursued interests other than art. While

on vacation in 1961, he and Sheila, his wife of three years, fell in love with the island of St. Thomas in the U.S. Virgin Islands. They left New York soon afterwards and began a new life. When a prospective business venture fell through, Larry, now thirty, began painting watercolor scenes of his island paradise in order to survive—this despite the fact that no one before him on the island had succeeded exclusively as a painter. But succeed he did! Within a few short years, his renown spread throughout the Islands to the United States and Europe. By 1970, thirty-five hundred paintings hung in collections throughout the world. Larry had made a complete mockery of the idea that one could not succeed as a representational painter.

In 1971, Larry, Sheila and their two children left the Virgin Islands and settled in Los Angeles, where he was soon to experience another life-changing lesson.

So many friends and acquaintances had asked to study with him that Sheila finally persuaded him to teach. To his amazement, he realized that no method of instruction existed to give students a thorough fine art foundation—the kind given to Rembrandt, van Gogh or even Picasso. At that moment Larry dedicated himself to recovering the knowledge that could provide others with the proper information and instruction to succeed at art.

And so, in 1975, Mission: Renaissance was born with the goal of reinstating the traditional basic skills of fine art. Larry pioneered the first complete step-

by-step fine art program, uncovering and codifying every single step needed for any beginner to travel a straight path to artistic excellence. He created a unique method of coaching students individually, as well, to ensure that each would succeed.

Using his revolutionary methods, not only did students with natural talent succeed, students who considered themselves devoid of natural talent were equally successful and became just as competent. The myth that one must have natural talent to succeed at art had been shattered.

With the door to artistic success now wide open for anyone, Mission: Renaissance has become the world's largest fine art program, with thousands attending classes weekly in the United States and Canada.

Larry and Sheila still reside in Southern California near their children and six grandchildren. Both continue to play an active role in the expansion of Mission: Renaissance.

STUDENT SUCCESS STORIES

"I have always wanted to learn to draw but believed it took 'natural' talent. I then heard about Mission: Renaissance and decided after 37 years of not trying it I would give it my best shot. I can't believe how fast and easy it was to learn the techniques. I expected to spend years reaching the point I've reached in just two months. It has truly changed my life, by opening up a creative side that I thought I didn't have."

B. T., Adult Student

"Mission: Renaissance is my first attempt at visual arts. All the art classes I took in high school and college were music; I believed that visual arts was something you're born with. I have now gone from not being able to draw anything to having the tools to draw anything. The course is so well laid out and organized, it allows a person to learn very efficiently how to draw. I don't like to waste time or money. Mission:

Renaissance doesn't allow you to waste either. I can't think of any better way to learn."

K.K., Adult Student

"I had majored in art in college during the '60s and '70s and I realized that during my formal education I hadn't really learned a thing. It was a do-what-feels-good philosophy and the end result was nothing. Mission: Renaissance is just what I needed to rehabilitate me as an artist and I really learned—for the first time in many instances!"

A.C., Adult Student

"Before I started this class I felt that I could not draw. Now I feel confident about my drawing."

K.P., Age 12

"My daughter has gained so much self confidence and self-esteem in the artwork that she has done, and we are so proud of her, too. We have seen other art classes but they cannot compare to the unique style of teaching that Mission:

Renaissance provides. I feel that this was the best investment we have made for our daughter. Thank you again for the wonderful experience you provided that she will carry with her for the rest of her life!"

L.A., Parent

"I like my artwork because it looks so real. I never thought I could draw such great art. I learned a lot. I want to be an artist when I grow up."

K.S., Age 7

"I think I've improved a lot. I have confidence in what I am doing and I'm proud. I want to draw forever and never stop."

M.D., Age 11

"I am a parent of two girls who attend class[es]. I originally enrolled my girls in your program because they have never been good at drawing. In fact, they have always expressed frustration in their inability to draw. From their

very first session at Mission: Renaissance they have been thrilled with the program. The results that they've had, along with the tremendous confidence that they build is immeasurable."

K.T., Parent

"I can honestly say I was close to very ignorant of art and the process of art as a whole. I sincerely thought I had no talent, much less skill or knowledge of art. I came here as a last resort before calling it quits in art, which also meant my dreams and hopes of becoming an artist would be gone down the tubes. I, like millions of other people in this world, consider art to be a mystery and the talent therein an unattainable goal that you were either born with or without. But Larry taught me that I could be an artist. Now, my dreams are within reach and are very real."

T.C., Teen Student

"Although I have inherited some natural talent in the art field, I have never learned the basics. To my surprise, after the first few lessons I had forgotten all of my old habits. After applying this new technique that I learned at

Mission: Renaissance, it felt so natural to sketch.

"In the past, I was just putting paint on a canvas and didn't have a feeling of confidence."

L.M., Adult Student

"Zachary's self esteem has soared in just the past few weeks due to his major leaps in his art abilities. His whole world has opened up. He beams."

K.H., Parent

"I learned tons about art in class; it was fun. I want to be an artist when I grow up and this made my dream come true."

J.K., Age 8

"I had no prior exposure to or experience with drawing since early childhood and I was convinced that I lacked talent. My three daughters [Mission: Renaissance students] exhibited a lot of artistic interest and ability and I was honestly envious of their confidence and enjoyment of the artistic process. So, I enrolled and learned

the technique. The tools you have shared with me are invaluable, and now I, too, have confidence. By the way, I have noticed that the rules for seeing in art apply to life in general. Thank you for teaching them with such openness and simplicity."

S.S., Adult Student

"Larry Gluck, you are the greatest! I have never drawn before in my life.... I am truly, truly, truly amazed that I am able to draw! It's like the ability happened and I didn't even see it coming!"

G.J., Adult Student

"I really love art class. I love the way I feel when I finish a painting. Art class has taught me to never give up... no matter what happens. I hope to be a great artist when I grow up."

E.D., Age 9

"I have been drawing as long as I have been able to hold a pencil. And though I have had this

continual urge to draw, it had also been a continual frustration to me. Mission: Renaissance has changed all that. I now know what I am doing and I am having fun sketching for the first time in my life."

D.W., Adult Student

"I never thought I had a talent for art until I went to Mission: Renaissance. It's amazing how quickly I improved."

A.B., Age 13

"I am amazed at my progress! My ability to utilize proper perspective and form has greatly improved. I still feel that nobody has tried to take away my own 'style,' but in fact have given me the tools to implement my style with greater clarity."

L.J., Adult Student

"Taking this course has made everything in life seem different, more alive! The way the course is structured, along with the excellent

instruction, makes it so easy to learn what you think is out of your league. I feel very proud of myself!"

R.L., Adult Student

"Wow! Doing this has helped me learn that I can accomplish things if I set my mind to it. I know I'll never be able to thank you enough. It's really amazing to look back at my previous drawings and know I've improved."

J.F., Teen Student

"Before I came here I knew nothing about art, or anything on how to draw. I am overjoyed with what I have learned here. Thanks!"

D.C., Age 11

"I came to Mission: Renaissance with the desire to be an artist, thinking somehow that being 'creative' was magical and only meant for a few. I learned that I could do it, not because I'm magically gifted, but because I learned to observe, decide, and visualize! Thanks for a new

freedom—freedom to create, freedom of thought, freedom of choice!"

A.P., Adult Student

"People don't need therapy, they need Larry Gluck's Mission: Renaissance Fine Art Classes. Thanks a billion."

J.K., Adult Student

Learn How to Draw at Home!

The Art of Drawing Home Study Course.

Larry Gluck shows you how with visual demonstrations and step-by-step instructions.

- World's premiere how-to-draw home study course.
- Visual demonstrations show you how.
- No "natural talent" required.

- Progress at your own pace.
- Clear-cut exercises & illustrations.
- Perfect for anyone age 12 and up.

**To order visit www.thegluckmethod.com
or call 1-800-430-4ART**

At Larry Gluck's Mission: Renaissance all the skills needed to create beautiful drawings and paintings await you—from how to hold a stick of charcoal properly, to mixing lifelike colors perfectly. You'll learn the true basics in a complete sequence of short, easy-to-learn steps, enabling you to use every fundamental skill.

At last… all of your questions will be answered. Never before has it been so easy to become a fine artist.

Call our registrars today to start becoming the artist you've always wanted to be:

1-800-430-4ART

Locations throughout Southern California.